ON THE MOVE

ON THE

MOVE

GREAT TRANSPORTATION PHOTOGRAPHS FROM

PHOTOGRAPHS FROM THE TIME INC.
PICTURE COLLECTION

EDITED BY MARYANN KORNELY
AND JENNIE HIRSCHFELD

INTRODUCTION BY DANIEL OKRENT

A BULFINCH PRESS BOOK / LITTLE, BROWN AND COMPANY
BOSTON | NEW YORK | LONDON

Published in association with Time Inc. Editorial Services

Visit our web site at **thepicturecollection.com**

Introduction copyright © 2000 by Time Inc.

Compilation of text copyright © 2000 by Time Inc.

Compilation of photographs copyright © 1999 by Time Inc.

Photographs copyright © by Time Inc. except those on the following pages:

 Pages 22, 67, 80 copyright © Estate of Margaret Bourke-White

 Page 126 copyright © Jon Brenneis

 Page 130 copyright © Joe Clark

 Page 100 copyright © Jerry Cooke

 Page 124 copyright © Gordon Coster

 Page 137 and back jacket image © Ralph Crane/Black Star

 Page 37 copyright © Andreas Feininger

 Page 138 copyright © Martha Holmes

 Page 60 copyright © Wallace Kirkland

 Pages 14, 57, 102 copyright © John Loengard

 Page 66 copyright © Arthur Mostead

 Page 104 by Carl Mydans for the Farm Security Administration

 Page 50 copyright © A. Y. Owen

 Page 122 copyright © Irving Schild

 Page 16 courtesy Ford Motor Company

 Page 84 courtesy Sikorsky Aircraft Corporation

 Page 17 courtesy WCPM Collection, Nebraska State Historical Society

For acknowledgments for permission to quote from previously published copyrighted material see pages 142-143.

First edition

Library of Congress Cataloging-in-Publication Data

On the move : great transportation photographs from Life/photographs from the Time Inc. picture collection / edited by Maryann Kornely and Jennie Hirschfeld ; introduction by Daniel Okrent. — 1st ed.

 p. cm.

 ISBN 0-8212-2622-3 (hardcover)

 1. Transportation — United States — History — 20th Century.

2. Transportation — United States — History — 20th Century — Pictorial works.

I. Life. II. Life Gallery of Photography.

HE206.05 2000

388'.0973'0904 — dc21 99-35351

The editors would like to acknowledge the following people who helped with the preparation of this book:

Claude Boral	Sandra Klimt
Janet Swan Bush	Allison Kolbeck
Scott Devendorf	Lisa Kyler
Madeleine Edmondson	Charles Lampach
Eric Fassett	Pamela Marshall
Heike Hinsch	J. Abbott Miller
Bette Lazar Homitzky	Larry Nesbitt
Bill Hooper	Tiffany Reed
Arnold Horton	Martin Senn

Designed by J. Abbott Miller and Scott Devendorf, Pentagram

Text research by Jill Benz Malter

Photo research by Gretchen Wessels

Bulfinch Press is an imprint and trademark of Little, Brown and Company (Inc.).

PRINTED IN GERMANY

Photographers like things that move. It may be the impossible challenge of it — after all, capturing motion in a single frame is almost an oxymoronic notion, as weird as suggesting you grab a fistful of ice to warm your hands. But there's a simpler esthetic impulse at play, too: motion is a beautiful thing, brief and evanescent, beyond delicate. The classics scholar C. Maurice Bowra once wrote that the "primary impulse in the arts is to give permanence to the fleeting moment, to bid it stay." And no one does that better than a great photographer.

What's remarkable is that photographers are better at it than videographers or film cameramen, who are limited by a paradox: because their pictures themselves move, there's little wizardry in making us see a car rush past or a plane rise to the sky. That's merely real life. But a still photographer who tries to catch the wind must be an illusionist. As difficult as it is to freeze motion, it's harder still to keep it moving once it has stopped. Alfred Eisenstaedt's Atlantic hurricane on page 71, or his furiously paddling Ghanaians on page 11, really shouldn't be called a still picture, for there isn't a dot of stillness present. Pictures like these, and so many others in this book, are feats of art and magic, astonishing progeny of the marriage of technical skill and imaginative power that a great photographer brings to a moment in time.

There's something else that's curious about the attraction photographers have to planes and trains and cars and all the other hurtling vehicles of our just-ending century. They like them when they're motionless, too, when the absence of motion exalts the object — its sinuous shape, its delicious curves, the implied energy in its sheets of steel and iron. Loomis Dean's cars at a Los Angeles drive-in restaurant

(pages 114–115) and Margaret Bourke-White's shot of a TWA plane poised for take-off (page 80) contain something nearly as powerful as motion: the promise of motion unrealized, of speed about to be experienced. Or of the trip not yet taken.

For what brings this collection of photographs together is the simple notion of going from here to there, which is as much an animating instinct for our species as the urge to eat or breathe. The sea, the sky, the road — as powerful as their pull is for you and me, imagine what it's like for that species of nomad known as the magazine news photographer.

In 1944, *Life* staff photographer Bob Landry was on assignment aboard an aircraft carrier in the South Pacific. Then, as now, it was customary for writers and photographers to file periodic expense accounts when they were away from home on extended assignments, and the money would zing back to them by wire for use on the road or be dropped directly into a stateside bank account for a wife or a roommate to draw on to pay the rent.

But while he was on this particular assignment on the carrier, one of Landry's expense account filings ran afoul of the home office's bookkeeping procedures, and a cable came shooting back from New York: JUSTIFY EXPENSE ACCOUNT ITEM: TAXIS. Landry's wire back, deservedly preserved in the corporate archives for half a century now, was a message in behalf of every photographer whose work had taken him or her away from home for too long: DAMN BIG CARRIER.

Even punctilious accounting clerks couldn't dampen the spirit of photographers whose pride rested on their ability to go anyplace, at any time, to get the right shot. Carl Mydans, one of the great *Life* war photographers (two of his Second World War pictures, from Rome and from Chunking, are on pages 128–129 and 28), said, "When the war with Japan begun, I was exactly where I should have been: in Manila under Japanese attack." That was one way of doing it: to follow the news wherever it took you, and ask questions later. And if the means of conveyance made a picture itself (like the dive bombers Frank Scherschel flew with on page 87), so much the better.

A second variety of picture making that comes to play frequently in this volume is far more considered, even arranged. Perhaps the master of this form of shooting was Margaret Bourke-White — the greatest of all *Life* photographers, at least judging by her ability to create totemic images. Eleven of her pictures are included in this book, among them my own favorite, the DC-4 suspended over midtown Manhattan (pages 82–83). This isn't the sort of picture that happens because you're following the news or keeping your eyes open for the small moments that make up the life around you. This is a picture you invent in your imagination, and then you go out and make it happen.

The first famous pictures depicting Bourke-White herself showed her leaning perilously over the shoulders of a gargoyle 620 feet up the face of the Chrysler Building, and she seemed to be similarly airborne for much of the rest of her career. She loved working in the sky; in planes, she said, "the camera becomes a new instrument, because it's the camera and airplane working together." She also said that if the pilot "knows what you're doing, then he knows instinctively, like a good husband...who understands what his wife wants." For the DC-4, shot in 1939, Bourke-White wanted the glistening bulk of the plane, moving at high speed, to

stop, to hang as if attached to a string, at just this spot, over just these buildings, in just this light. Needless to say, she pulled it off.

And then there's the third kind of great photojournalistic picture: the one you get almost by accident. Before television's ascendancy was complete, nothing moved *Life*'s editors more than camera coverage of a breaking news event. So when the Italian liner *Andrea Doria* collided with the Swedish ship *Stockholm* in the Nantucket fog on a July night in 1956, the vast *Life* news team was instantly mobilized; within eighteen hours, twenty-four reporters and eight photographers had covered every shade and nuance of the story.

But the picture that would become the iconic representation of the wreck (page 70) was shot by a *Life* photographer who just happened to be passing by. Traveling to Paris with his family aboard the *Ile de France,* which was in adjacent waters to the *Andrea Doria* that night, Loomis Dean was awakened by a midnight knocking on his door. The magazine's publisher, Andrew Heiskell, who was also aboard, told Dean that he might want to get his cameras out. Dean had to wait for dawn to pierce the murk and fog of Nantucket Sound to take his picture, which was all the more dramatic for the distance from which Dean had to work and the conditions he had to work in.

The sine qua non of great documentary photography is not the camera, or the planning, or all the technical wizardry in the world, or even the unimaginable bravery of some of these men and women. It's the photographer seeing something — seeing a helicopter and making elaborate plans in order to capture its whirring blades (as Andreas Feininger did for the picture on pages 20–21), or seeing, without anticipating it, an unforgettable shot in a train car full of mere newspaper readers (as Mydans did for the memorable picture on page 44).

But enough of the ins and outs of photojournalism; the beauty of the pictures in this book comes from the simple wish to hit the road that motivates the rest of us nearly as much as it does the great shooters. (And even some of the less-great shooters, the few who, fortunately, were around to snap some of the pictures in the Mansell collection of historic photographs, such as the gems on pages 18–19). Trains and boats and cars and planes (and the occasional horse or rickshaw) are simply irresistible. They do more than move us through physical space; they take us through time as well. Just look again at the cars in Dean's drive-in restaurant shot and tell me you don't want to turn the clock back to 1949. And if *that's* not moving, then nothing is.

Egyptian fishing boats, Suez Canal near Port Said, Egypt, 1935 **Alfred Eisenstaedt**

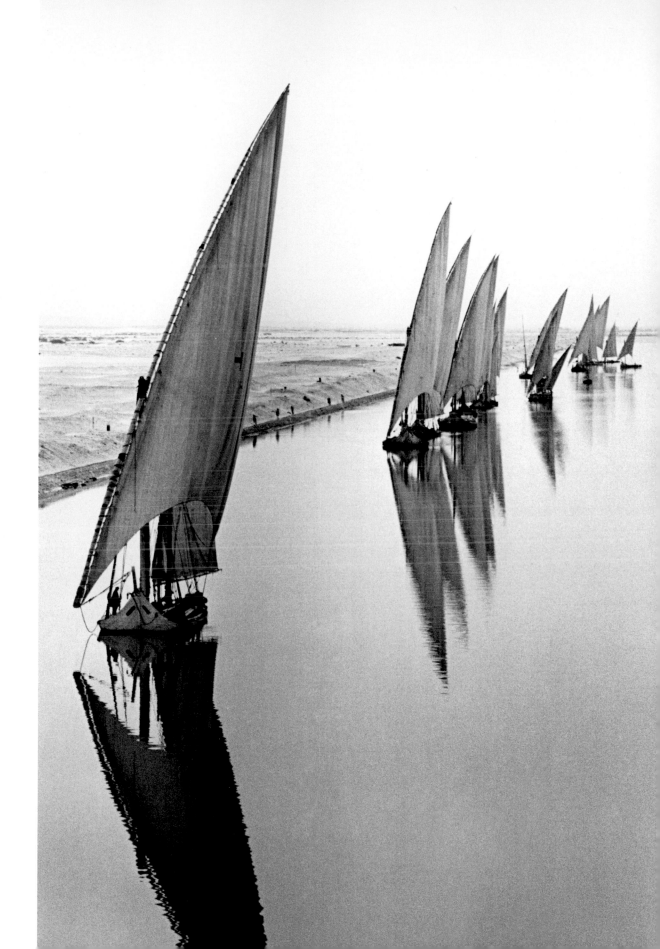

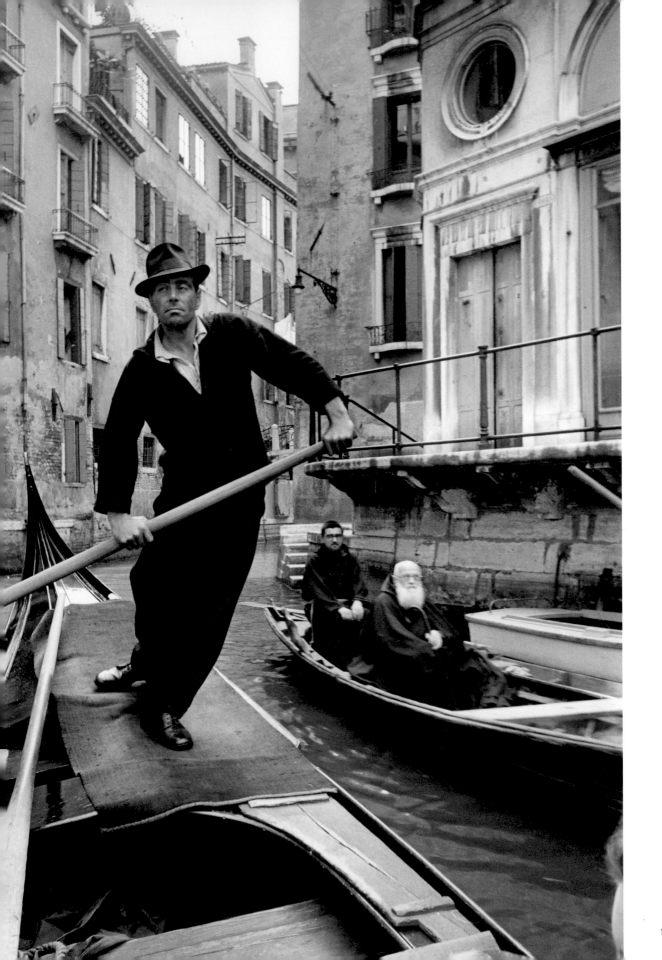

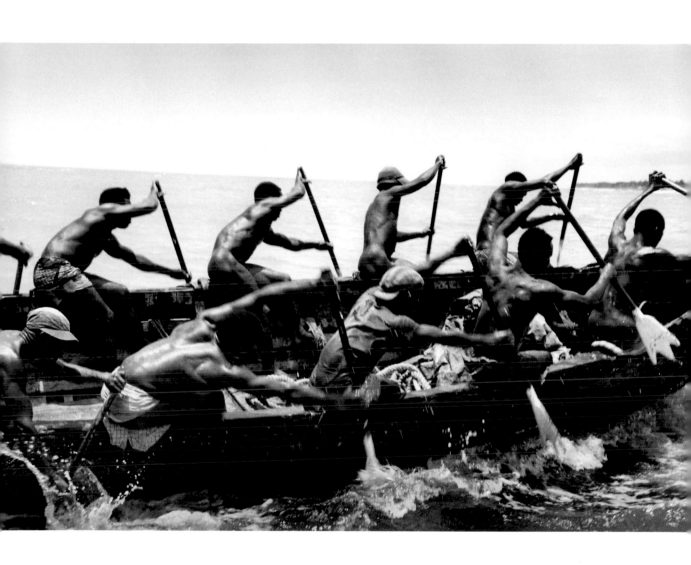

↑ Ghana tribesmen paddling, Ghana, 1935 **Alfred Eisenstaedt**

← Gondolas in Venice, 1947 **Alfred Eisenstaedt**

↓ Horse-drawn tramway car, Izmir, Turkey, 1934 **Alfred Eisenstaedt**

→ Chinese trackers towing Yangtze River junk, China, 1946 **Dmitri Kessel**

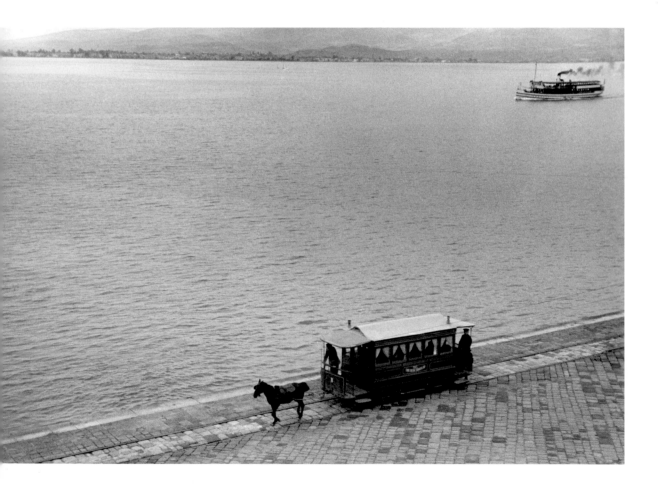

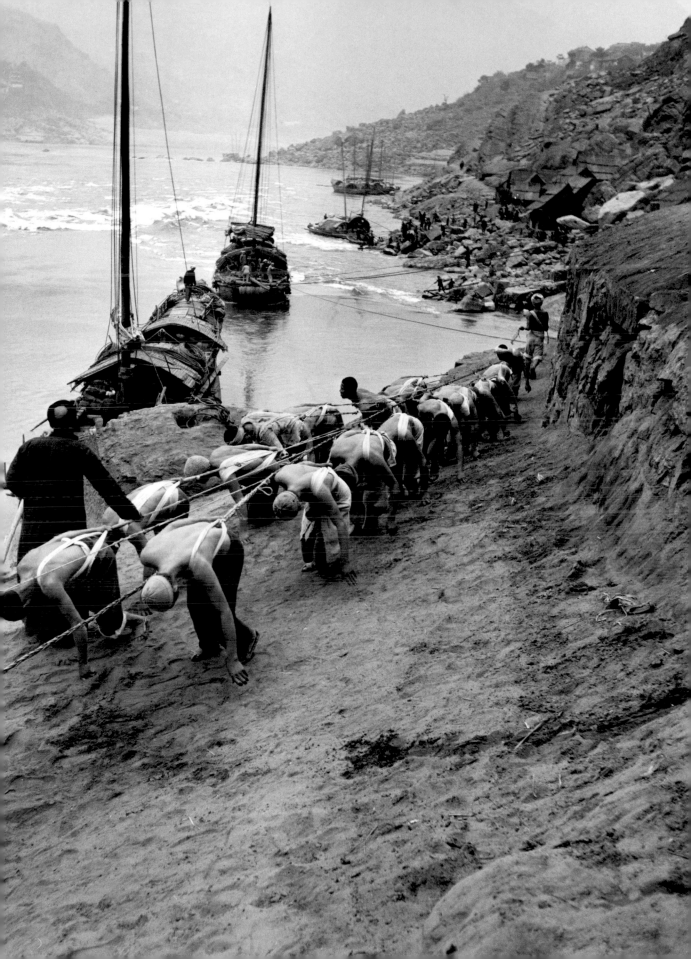

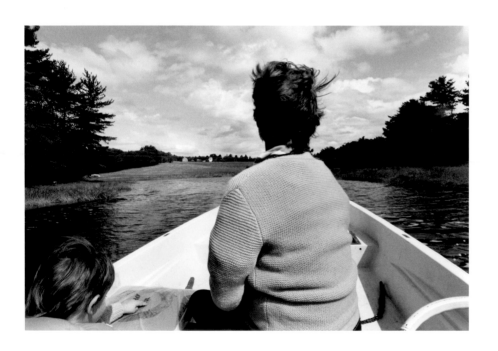

↑ A mother and son returning home by boat, Woolwich, Maine, 1966 **John Loengard**

→ Cowboy sitting in the shade of his horse, Texas, 1949 **Leonard McCombe**

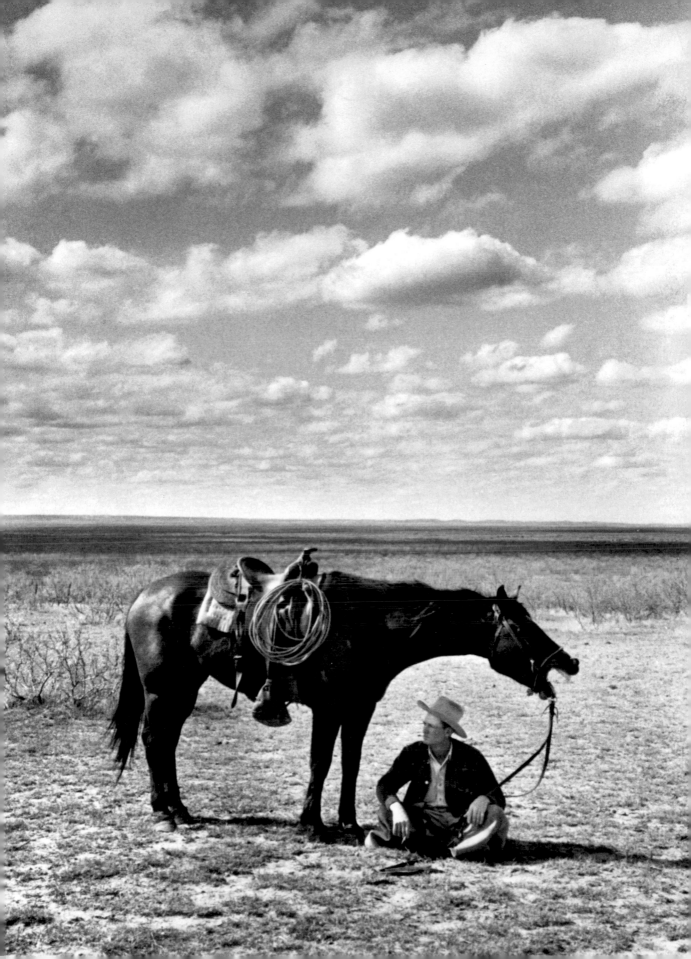

IN THE BEGINNING, ALL CARS WERE SPORTS CARS.

Only the most venturesome travelers chose the automobile over the more reliable trains and horses of that era. When the internal combustion engine at last became useful, it was simply bolted into the front ends of wagons and carriages, where the horses used to be. David E. Davis Jr., "The Freedom of Wild Ducks"

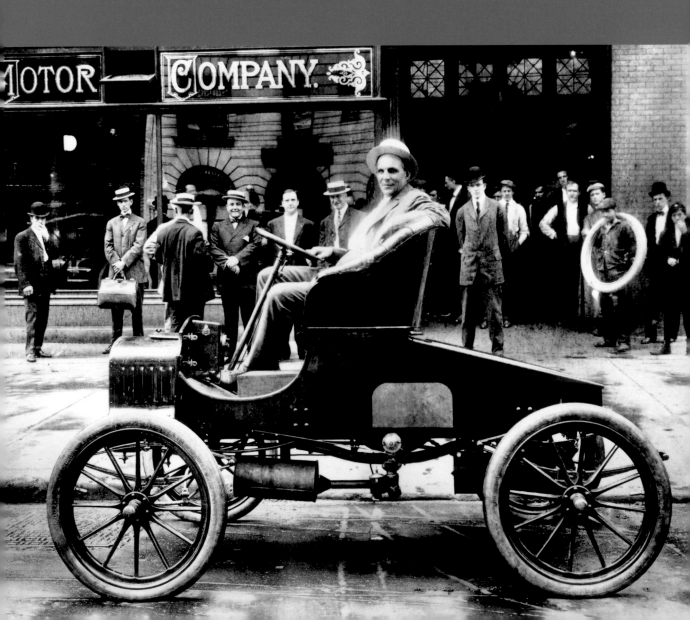

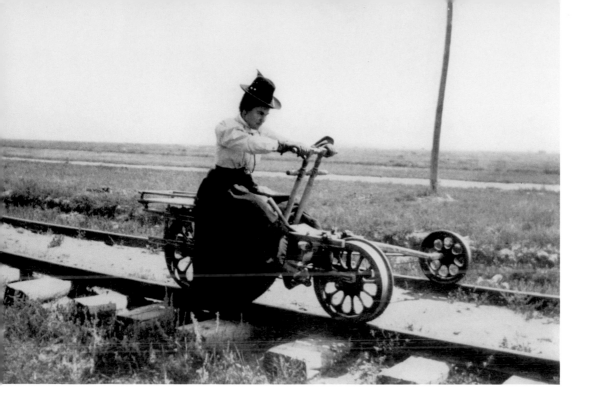

↑ Willa Cather on her way to visit her brother Douglas in Cheyenne, circa 1900.
He was station manager on the Burlington Railroad. **WCPM Collection**

← Ford car, Dearborn, Michigan, 1907 **Ford Motor Company**

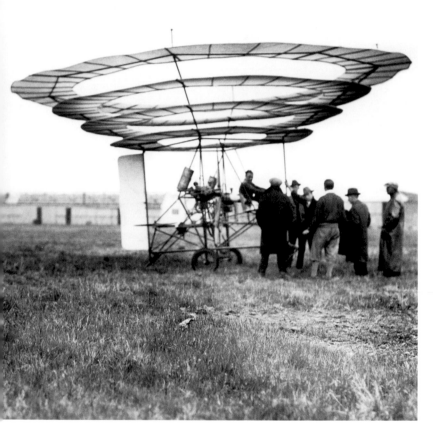

↑ "Flying Donut," Curtis Field, Long Island, New York, 1927 **Mansell Collection**

↗ Otto Lilienthal attempting to fly one of his gliders in Germany, circa 1895.
Wilbur Wright called Lilienthal "the greatest of the precursors." **Heig Block, Mansell Collection**

→ The Wright brothers' plane making its first successful flight, piloted by Orville Wright,
at Kitty Hawk, North Carolina, December 17, 1903 **Mansell Collection**

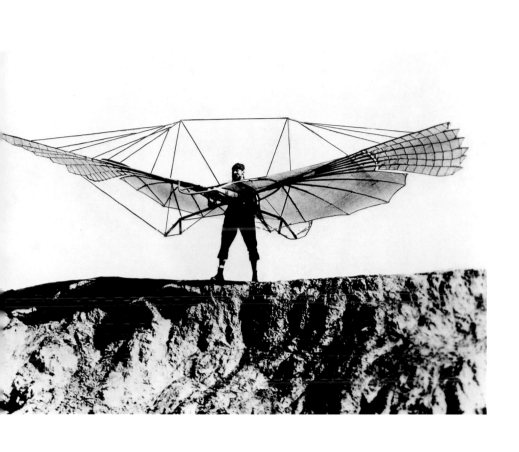

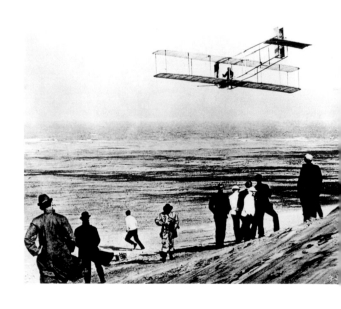

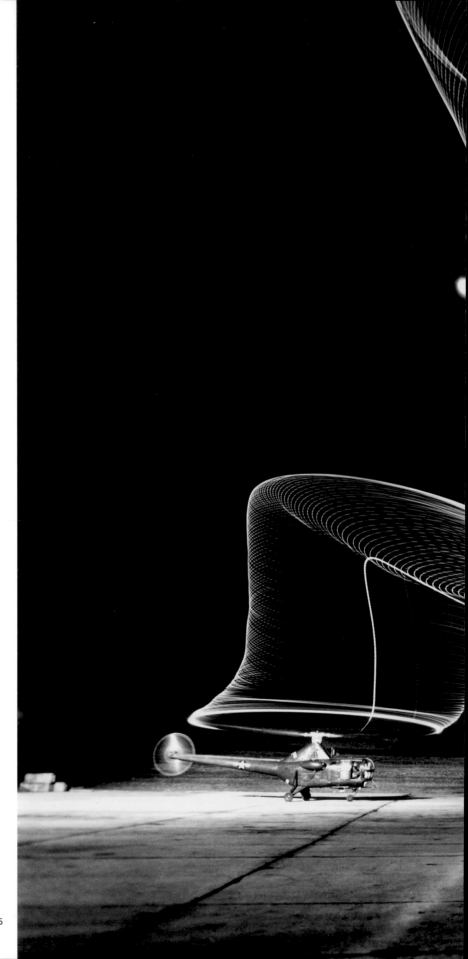

Navy helicopter, 1949 **Andreas Feininger**

OVERLEAF The Indianapolis 500, Indiana, 1935
Margaret Bourke-White

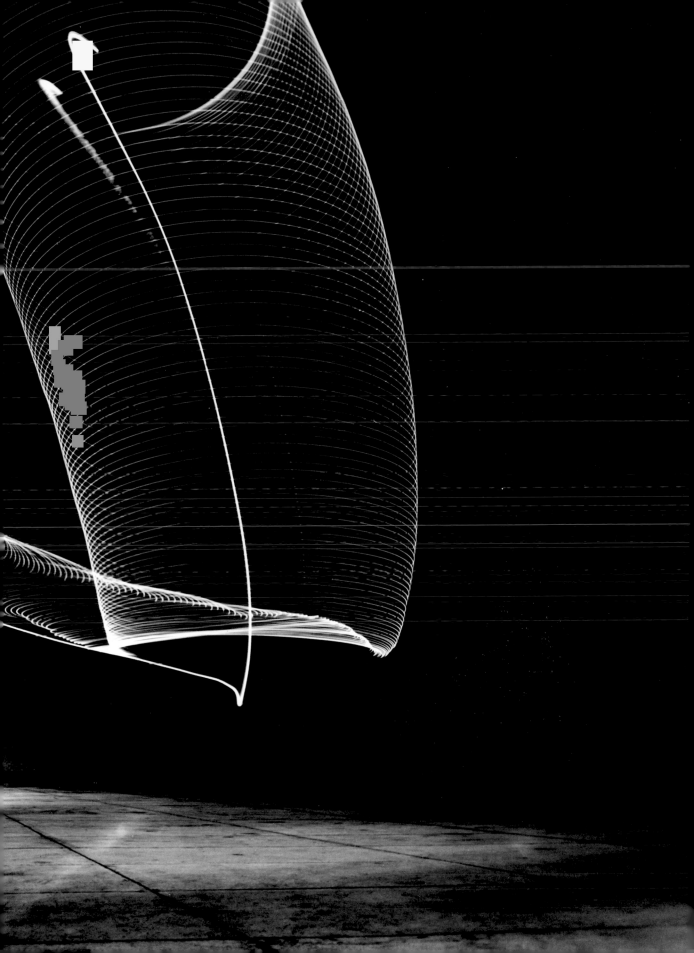

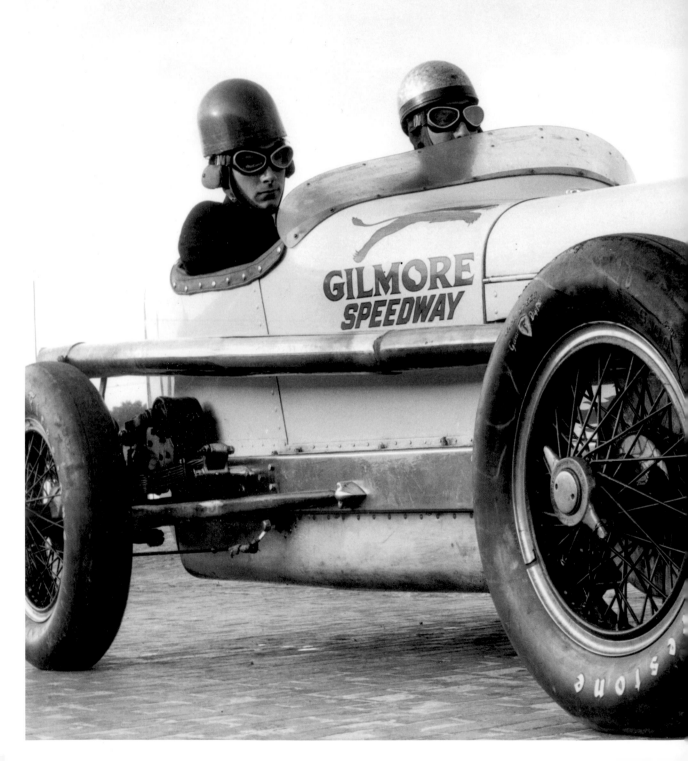

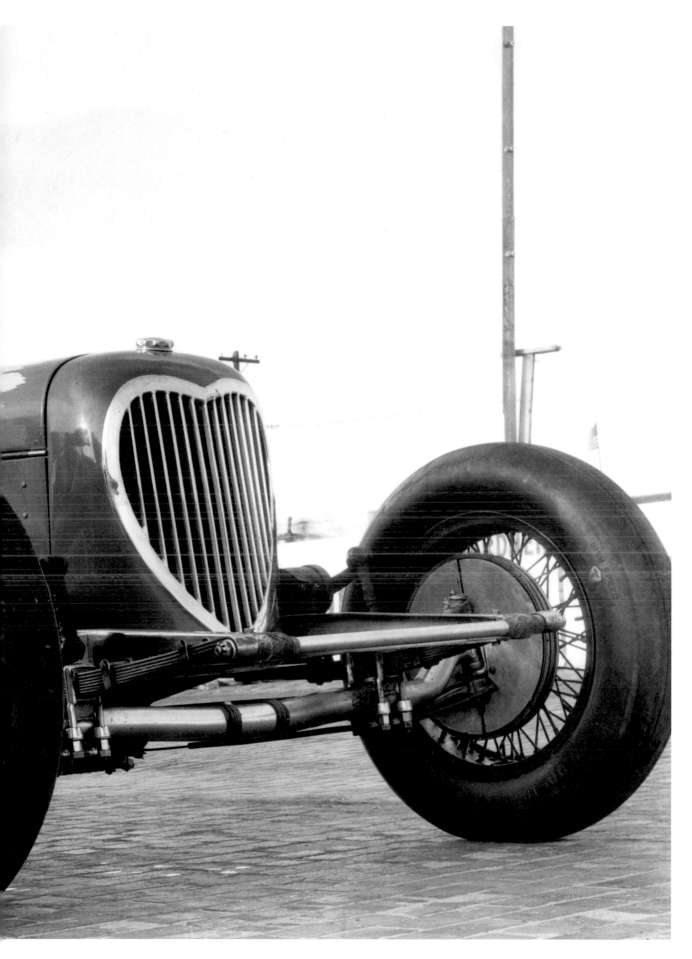

WHEN I TRAVEL
I DREAM A GREAT DEAL.

Perhaps that is one of my main reasons for travel. It has something to do with strange rooms and odd noises and smells; with vibrations; with food; with the anxieties of travel. Paul Theroux

A boy and his dog looking at the newly opened New Jersey Turnpike, Elizabeth, New Jersey, 1952 **Albert Fenn**

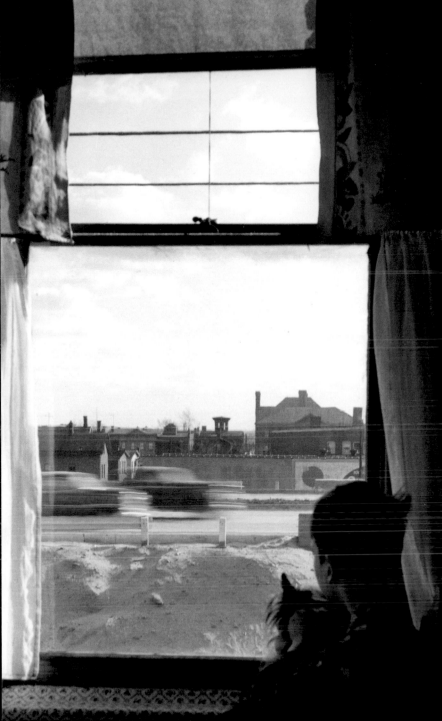

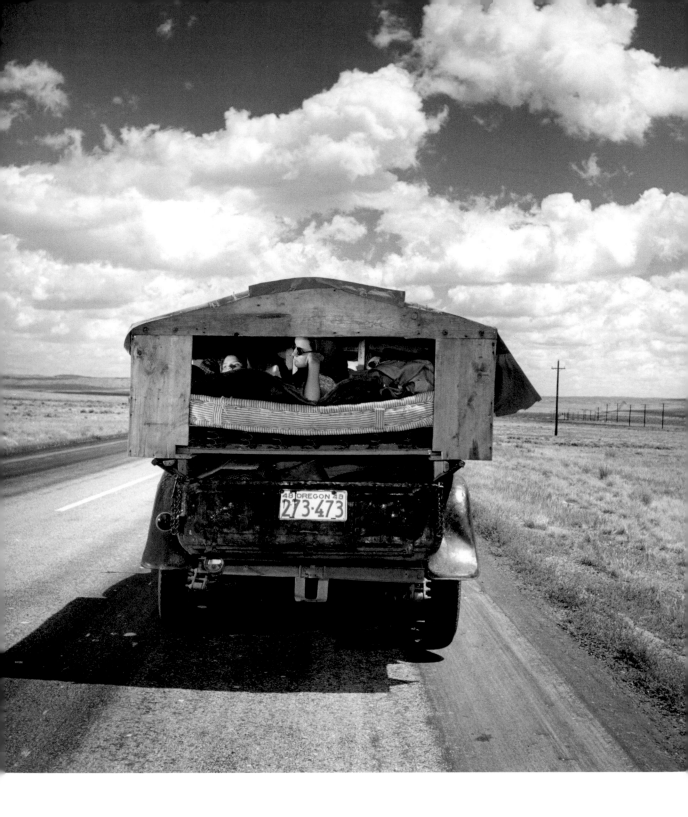

↑ A family from Oregon traveling on Highway 30, near Rock Springs, Wyoming, 1948 **Allan Grant**

→ U.S. ground crew preparing a dive-bomber at Midway air base in the Pacific, 1942 **Frank Scherschel**

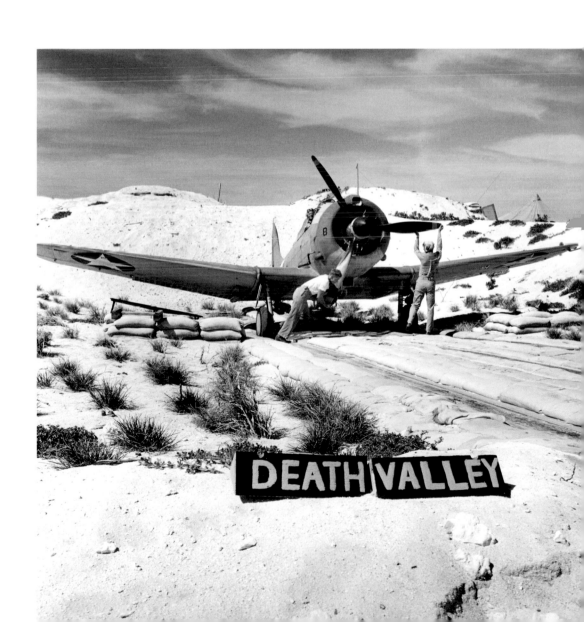

↓ Rickshaws in war-torn Chungking, capital of free China, 1941 **Carl Mydans**

→ Train jammed with Chinese returning to Mukden, Manchuria, after Japanese retreat, 1946 **George Lacks**

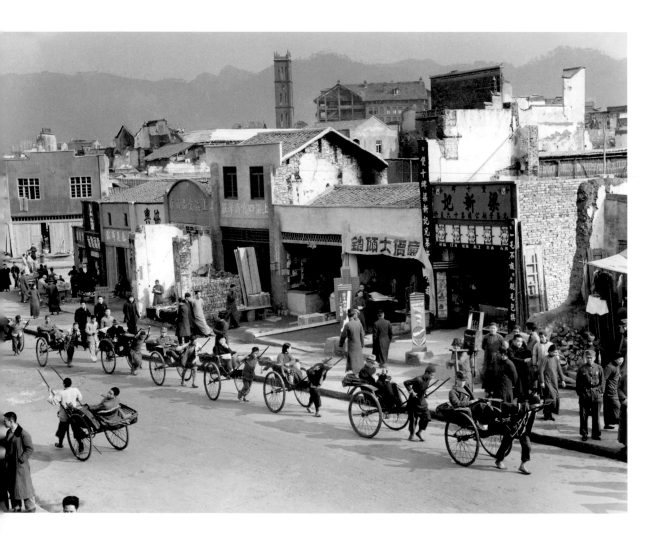

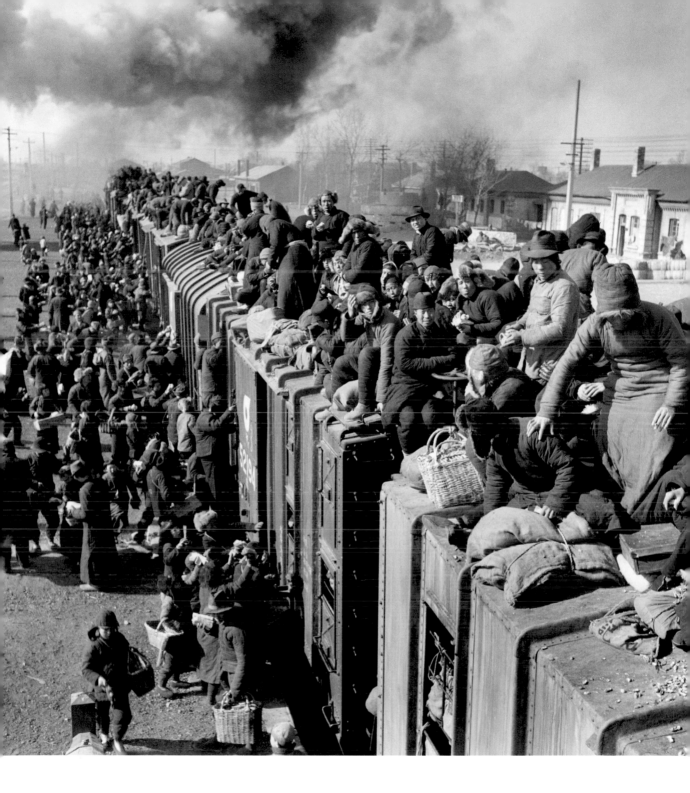

↓ A trench dug beside the Yellow River to supplant the railroad that was shelled in the Sino-Japanese War, China, 1941 **Carl Mydans**

→ A crew clearing train tracks after a heavy snowstorm, Japan, 1946 **Alfred Eisenstaedt**

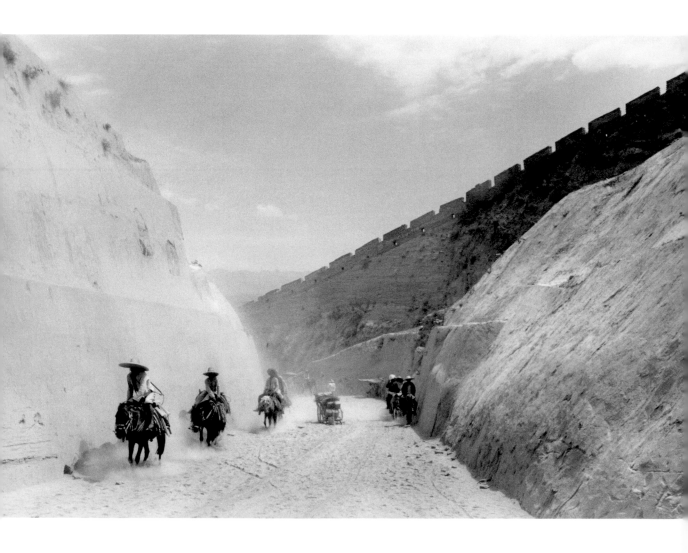

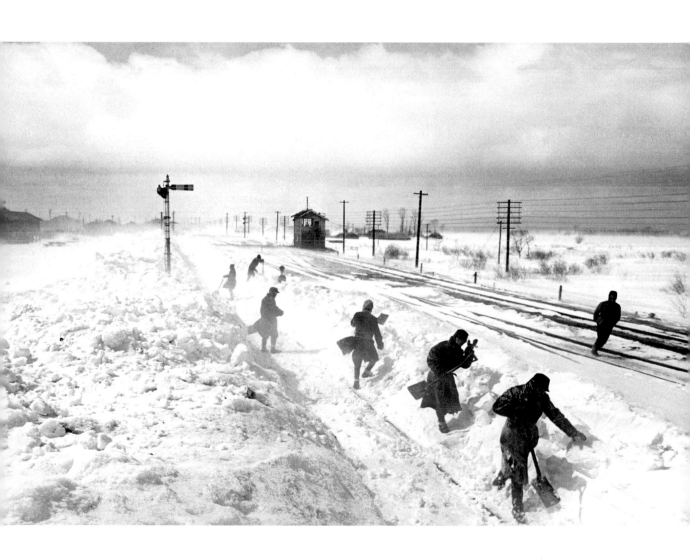

IN THE OLD DAYS
WITH A STEAM ENGINE,

why, it was up to you to get that engine in. If something you could see was wrong, why, you could do nearly all the repairs yourself or put grease or oil or what was needed to bring it in. With the diesel, you got your throttle and a brake, same as an automobile. . . . In the old days, with the steam engine, you had steam leaks and all that. And in the wintertime there was times you could almost go over the road and barely see any crossings, with the steam leaking around the cylinders. **Bill Norworth, interviewed by Studs Terkel,** *Working*

A Southern Railroad train, Charlotte division, leaving on its next run, 1938 **Horace Bristol**

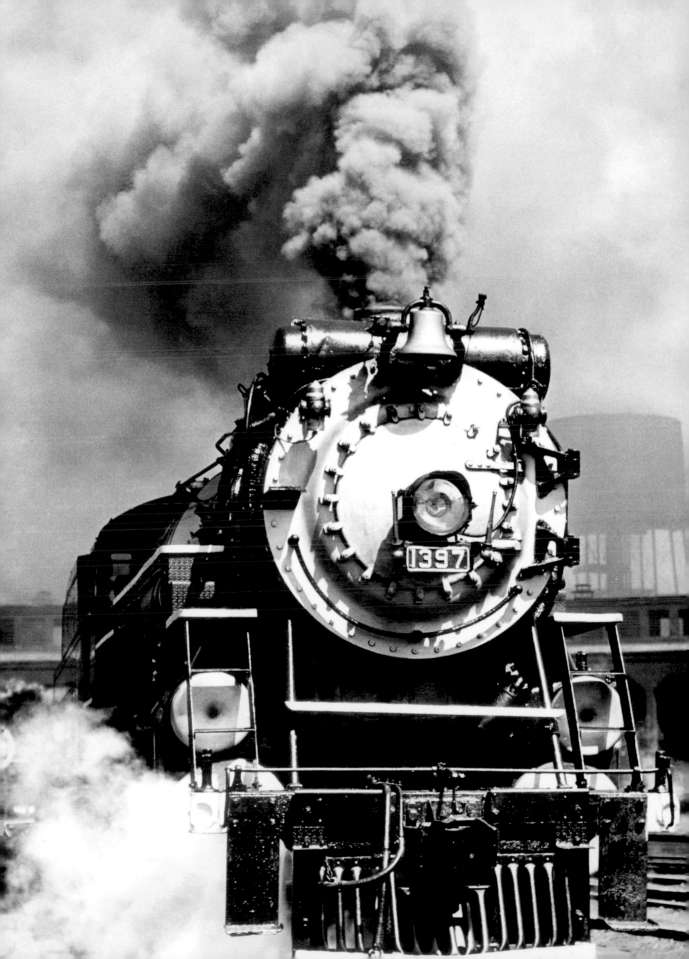

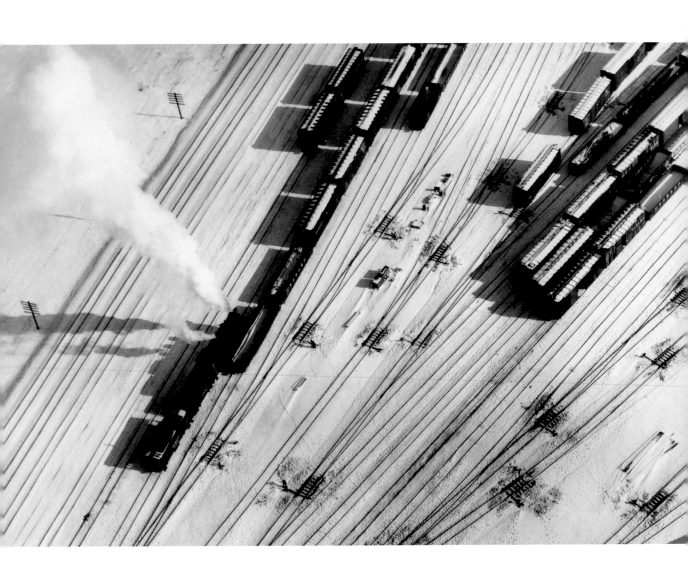

↑ Snow-covered train yard, south Chicago, Illinois, 1951 **Margaret Bourke-White**

→ Toy Train Society, Berlin, 1931 **Alfred Eisenstaedt**

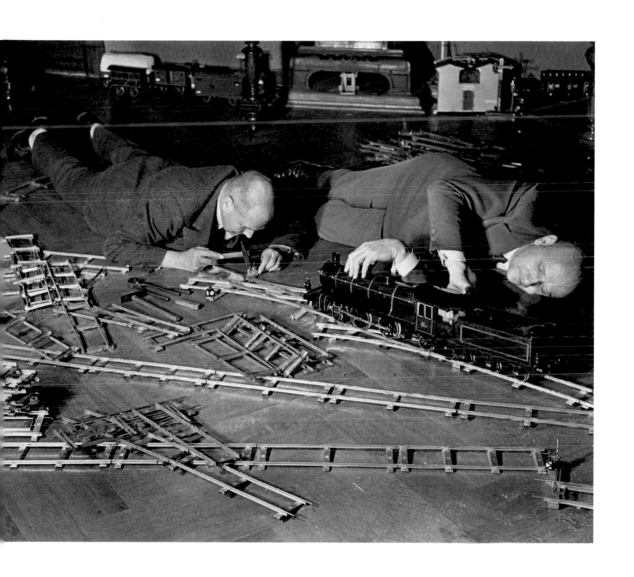

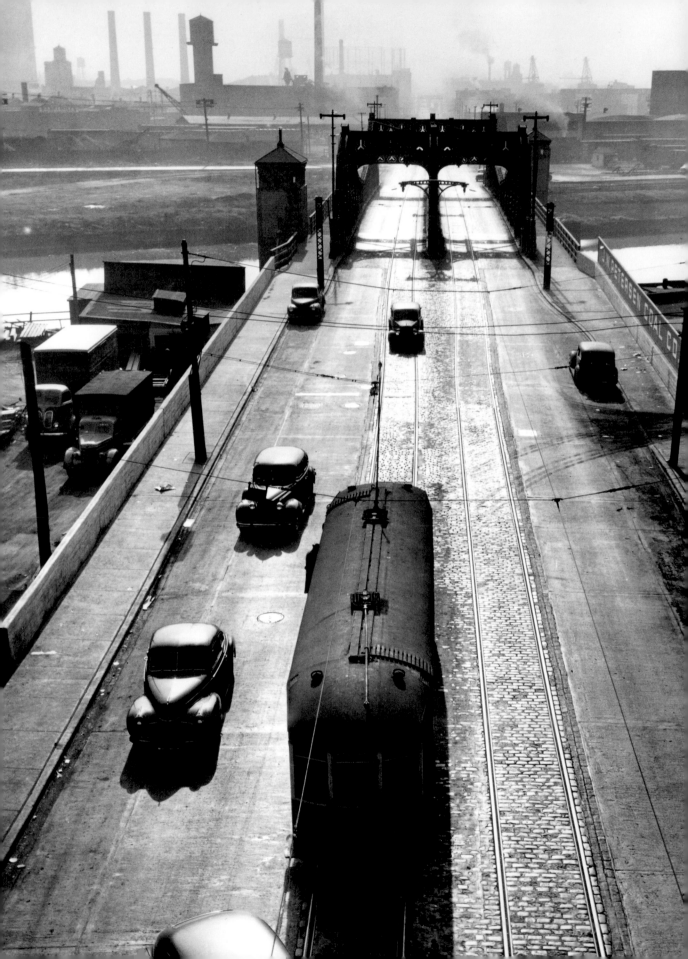

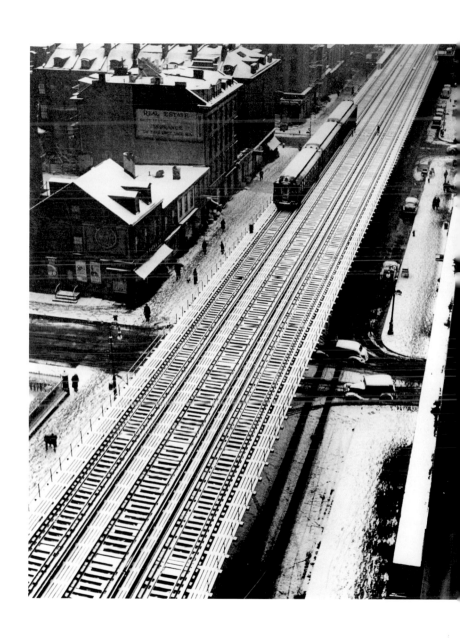

← Trolley car, Chicago, Illinois, 1944 **Gordon Coster**

↑ Ninth Avenue, New York City, 1940 **Andreas Feininger**

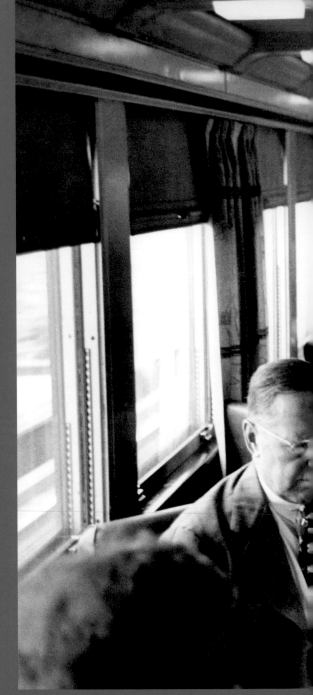

THE CLUB CAR

Come, child, while rambling through the nation
Let's practice our pronunciation.
The liquid confluence here we see
Of r-i-b and a-l-d.
When first potato chips he nibbled,
That gentleman was merely ribald,
But now that he is four-rye-highballed,
We may properly pronounce him ribald.

Ogden Nash

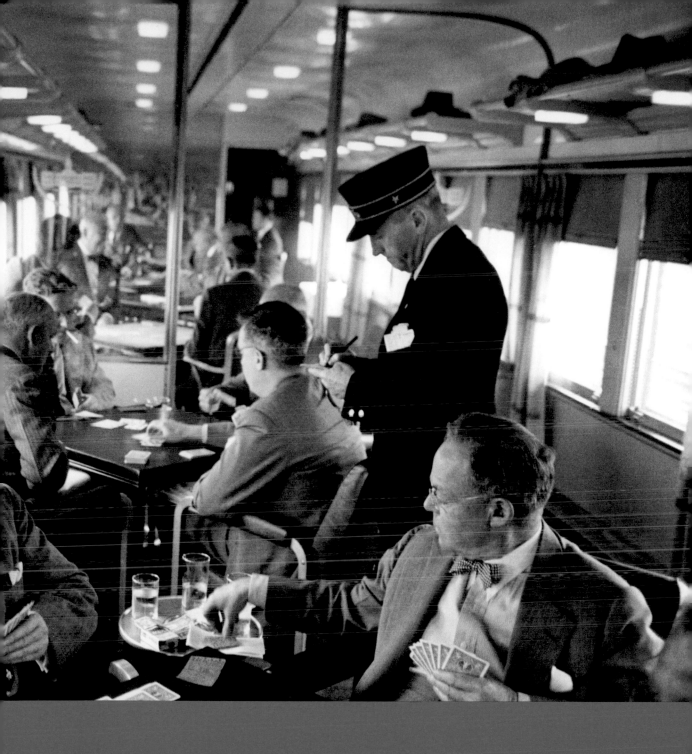

The club car of the 5:05 from Grand Central Station, New York, headed to Fairfield County, Connecticut,
on the New York, New Haven, and Hartford Railroad, 1948 **Peter Stackpole**

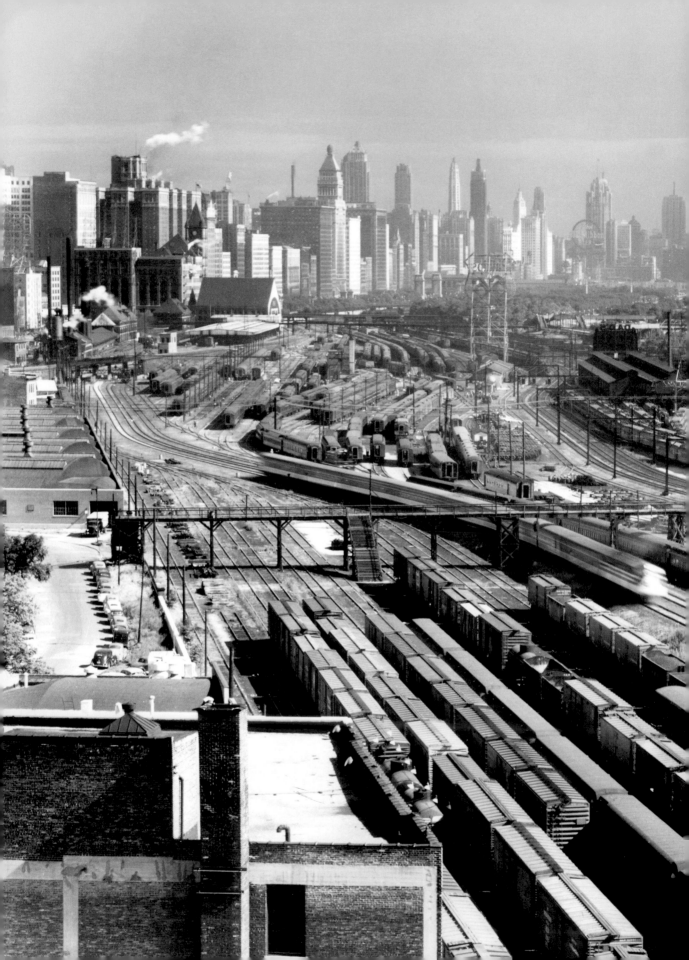

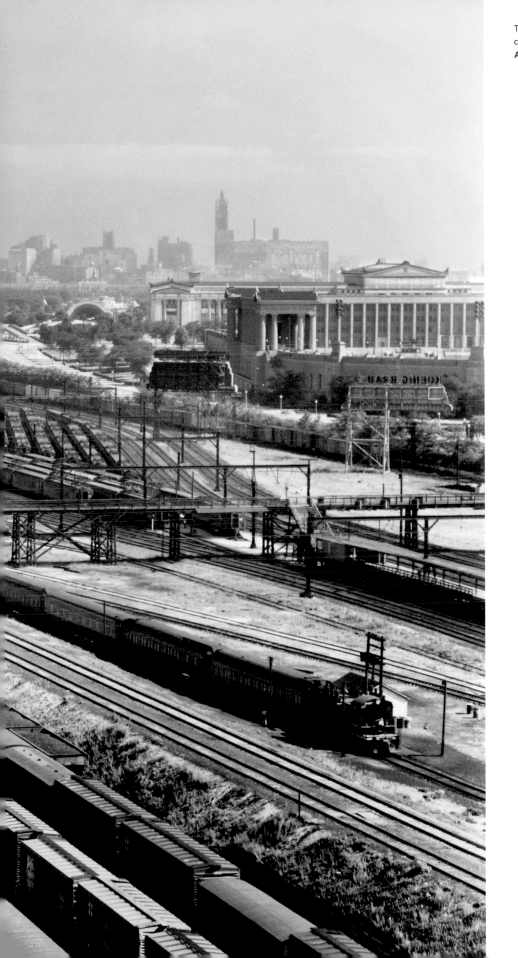

Tracks of twenty major railroads
converging at Chicago, Illinois, 1948
Andreas Feininger

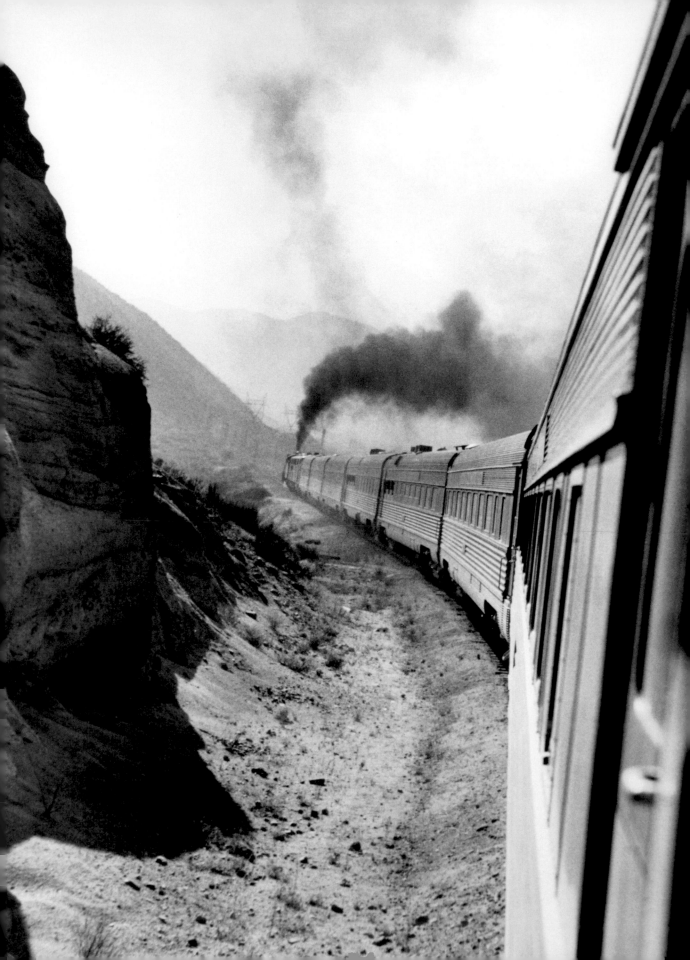

LEANING FROM THE CAB WINDOW,
WATCHING THE FLASH OF HER GREAT PISTONS,
watching the 2500-ton train come creaming along so obediently behind us, one soon began to think anything less than 60 mere loitering. All the imaginations that the cab might be uncomfortable riding were bosh. There is hardly – at any rate in those heavy 5200's – any more sway or movement than in the Pullmans themselves. The one thing a constant automobile driver finds disconcerting is the lack of steering. As you come rocketing toward a curve you wonder why the devil George doesn't turn a wheel to prevent her going clean off. And then you see her great gorgeous body meet the arc in that queer straight way – a constantly shifting tangent.

Andrew Carnegie, *Autobiography*

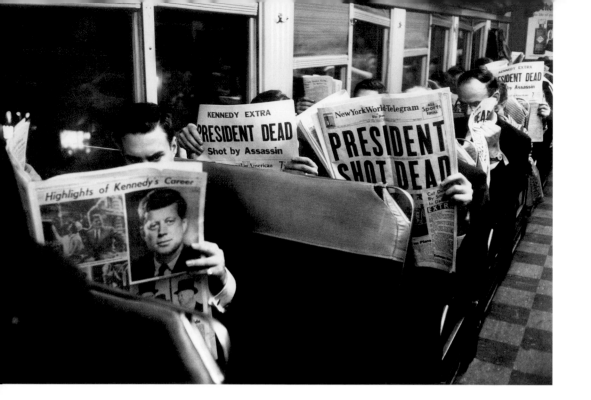

↑ On the 6:25 from Grand Central Station to Stamford, Connecticut, November 22, 1963 **Carl Mydans**

→ Meeting the 5:31 train from New York City, Darien, Connecticut, 1949 **Nina Leen**

HIGHWAY
66

is the main migrant road. 66 – the long concrete path across the country, waving gently up and down on the map, from the Mississippi to Bakersfield – over the red lands and the gray lands, twisting up into the mountains, crossing the Divide and down into the bright and terrible desert, and across the desert to the mountains again, and into the rich California valleys.

John Steinbeck, *The Grapes of Wrath*

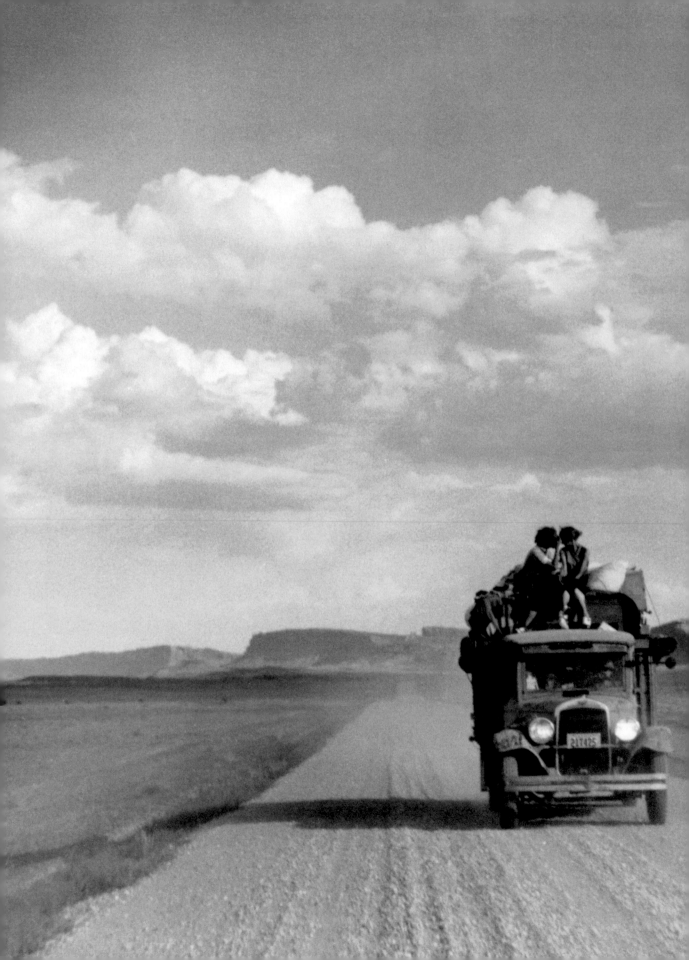

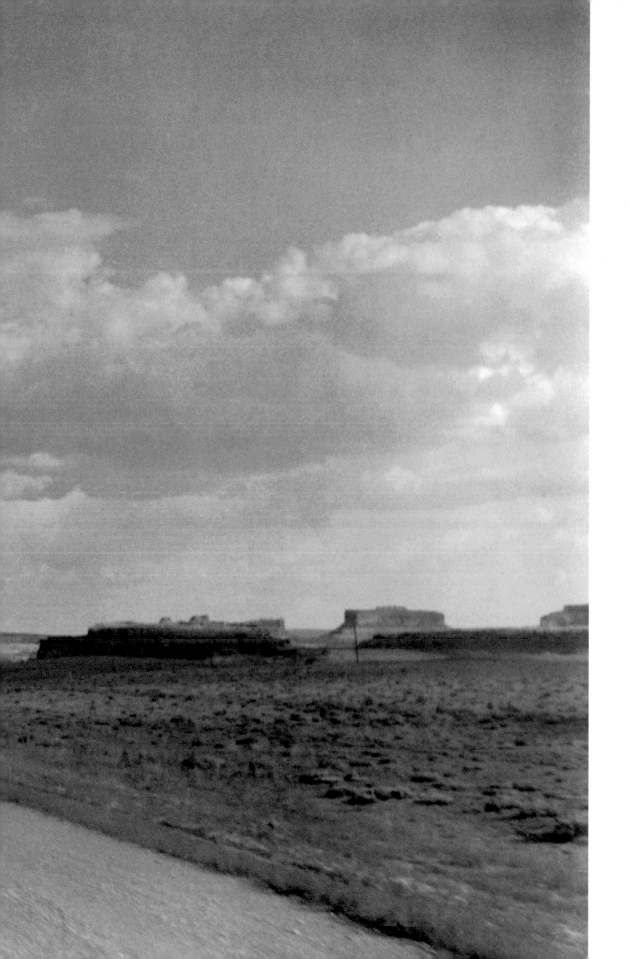

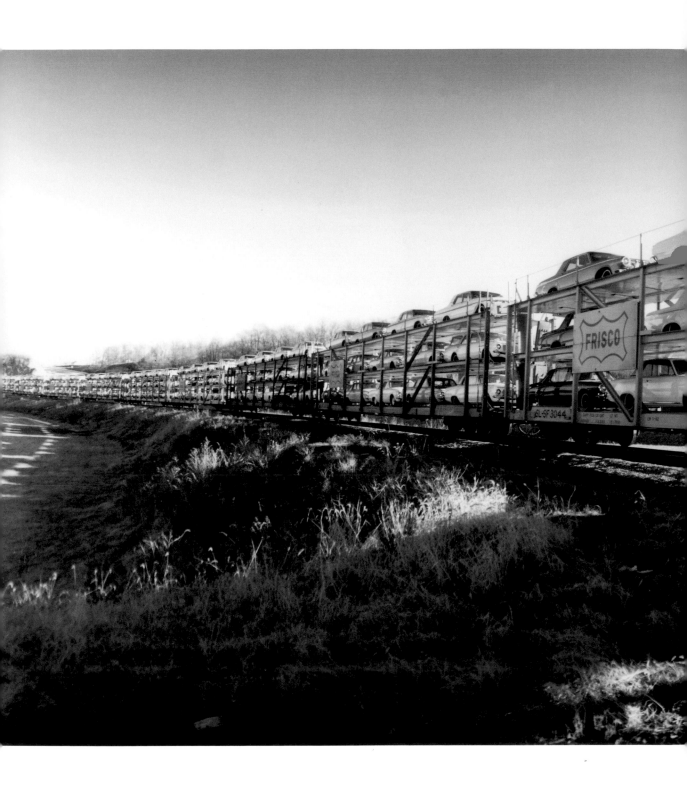

A three-tiered train on the Frisco line transporting new cars from the Chrysler plant in St. Louis, Missouri, 1962 **A.Y. Owen**

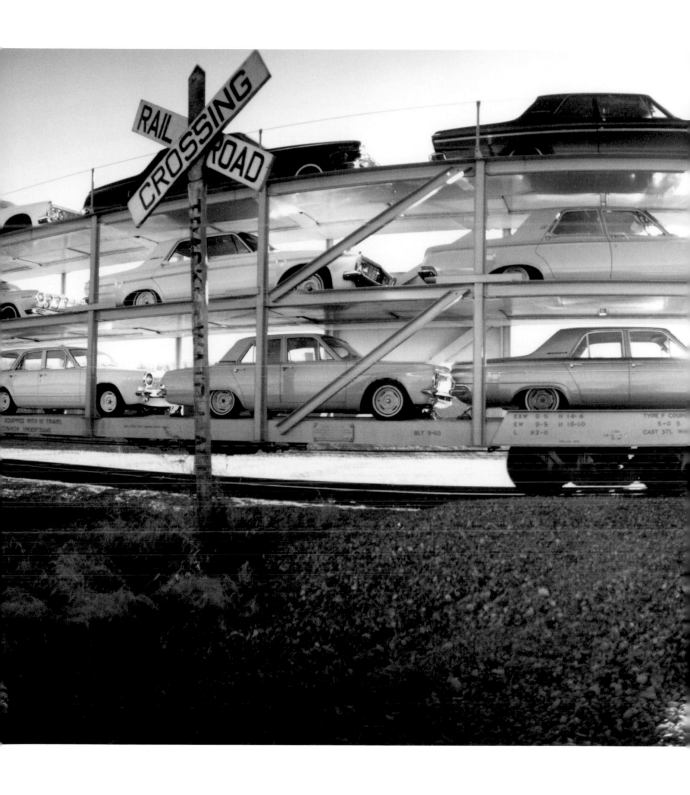

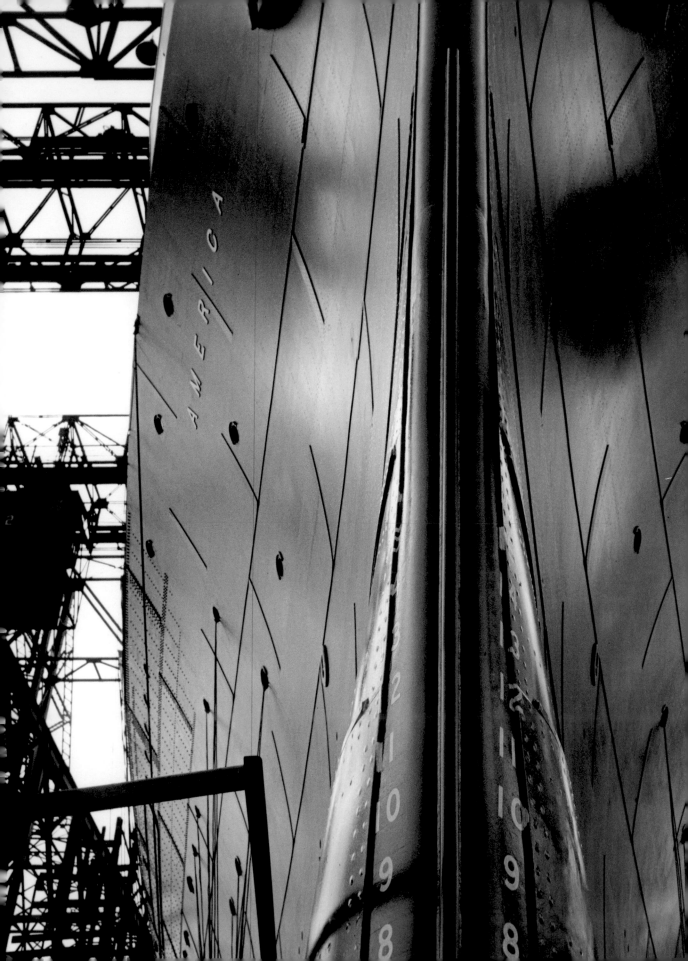

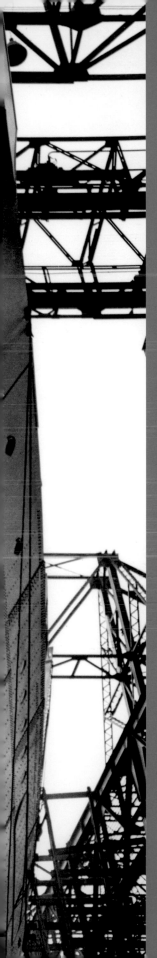

The *America* just before launching, Newport News, Virginia, 1939
Alfred Eisenstaedt

THE SHIP
SHUDDERED,
ROCKED AND HEAVED,
ROLLED SLOWLY

as the pulse of the engines rose to a steady beat; the barking sputtering tugs nosed and pushed at her sides and there appeared a slowly widening space of dirty water between the ship and the heaving collision mats. All at once by a common movement as if the land they were leaving was dear to them, the passengers crowded upon deck, lined along the rail, stared in surprise at the retreating shore, waved and called and blew kisses to the small lonely-looking clusters on the dock, who shouted and waved back.

Katherine Anne Porter, *Ship of Fools*

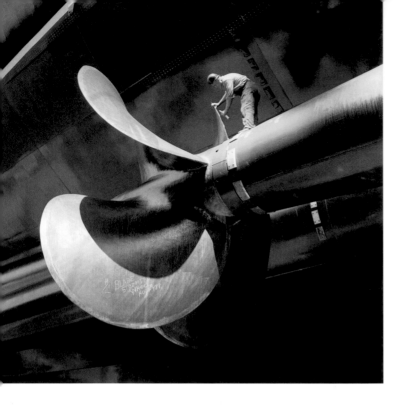
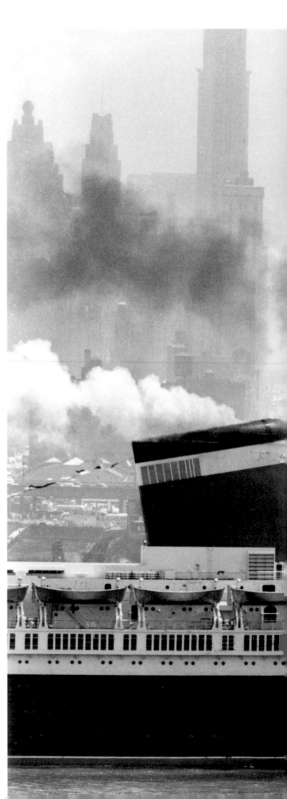

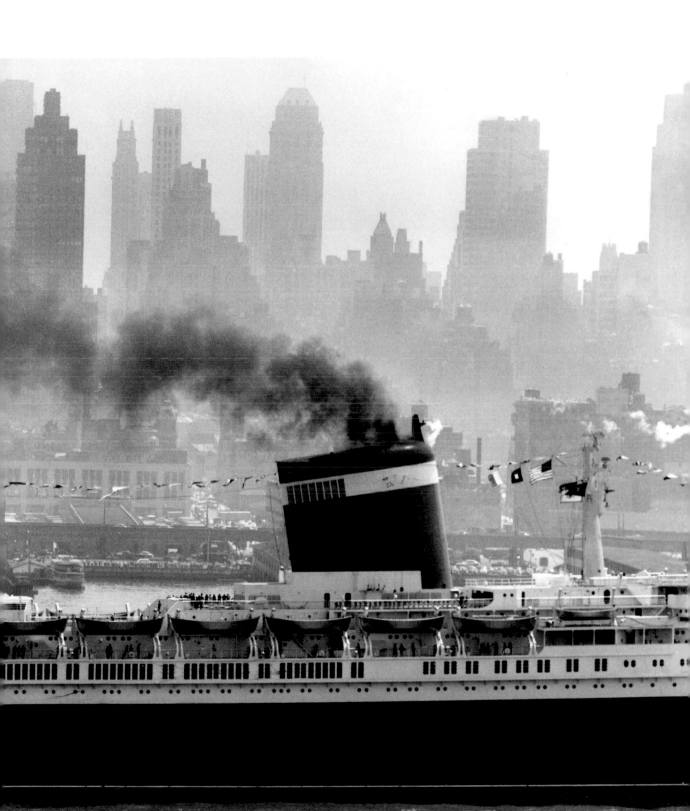

↓ The *Bremen* cruise ship, Bremerhaven, Germany, 1930 **Margaret Bourke-White**

→ Quitting time for construction workers on the *Queen Elizabeth II*, Glasgow, 1968 **John Loengard**

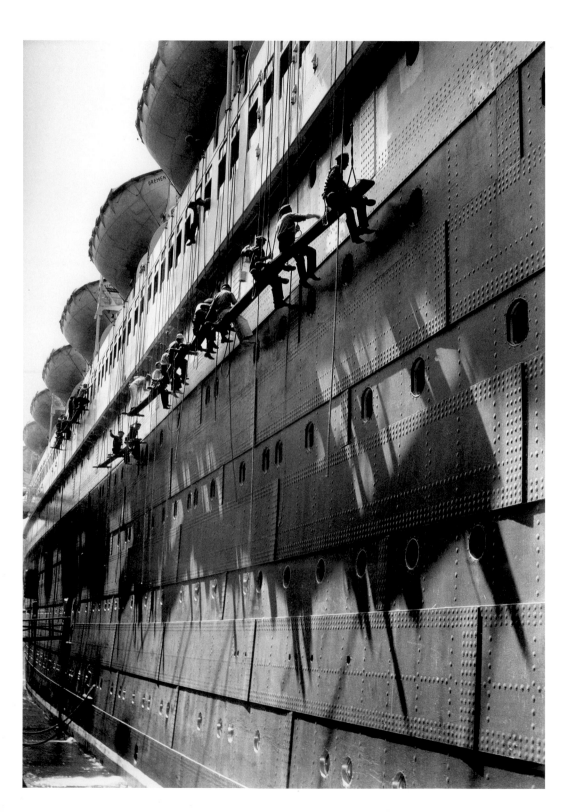

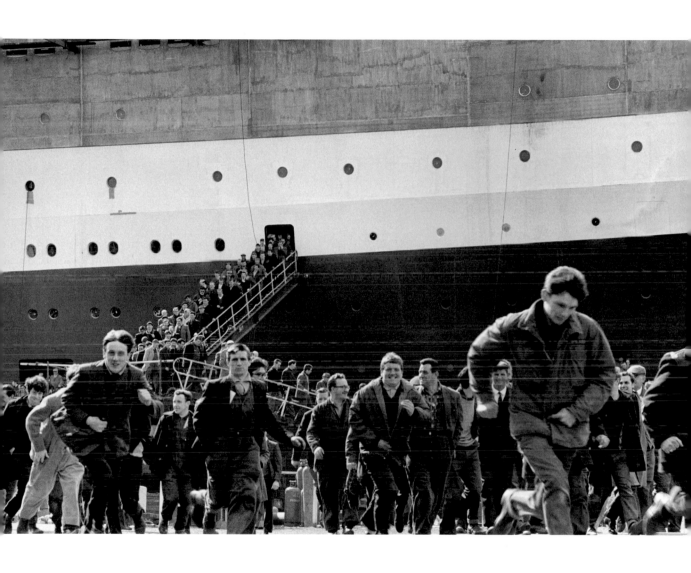

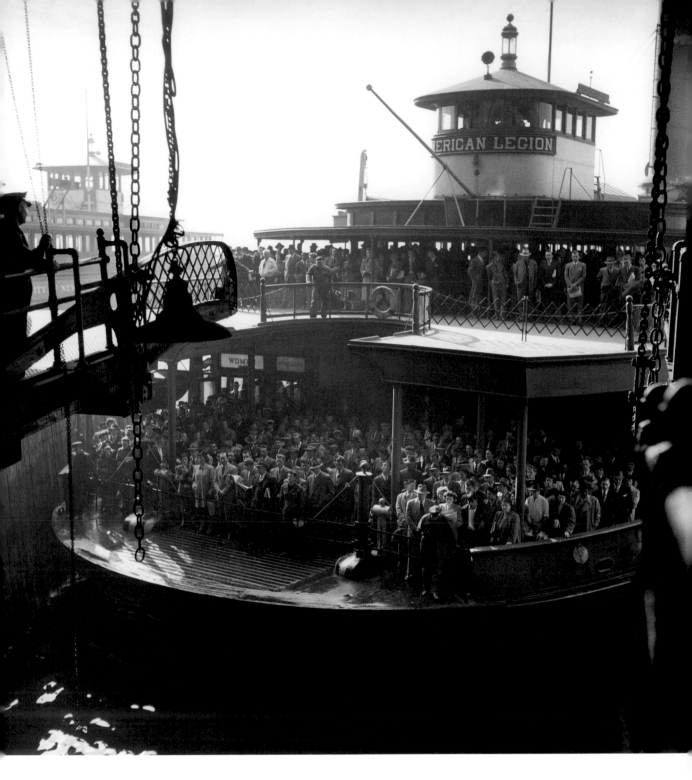

CLANG!

The concertina gate is opened, by a brawny boatman with his sleeves rolled up. There is a jangle of iron pawls, a creaking of planks. A slurp of muddy water, rich with cigar butts, old newspapers, bottles and oil slicks, rises and falls against the wooden timbers, and off the grimy ferryboat, with its tall black-belching funnel, the commuters from New Jersey fairly politely elbow their way along the pier, through the grim terminal at the bottom of 42nd Street, to fan out among the shops and offices of midtown. They are the descendants of the original commuters, the very word being a New York derivation from a commutation ticket – what the English still call a season ticket. Jan Morris, *Manhattan '45*

Staten Island ferry, New York, 1949 Andreas Feininger

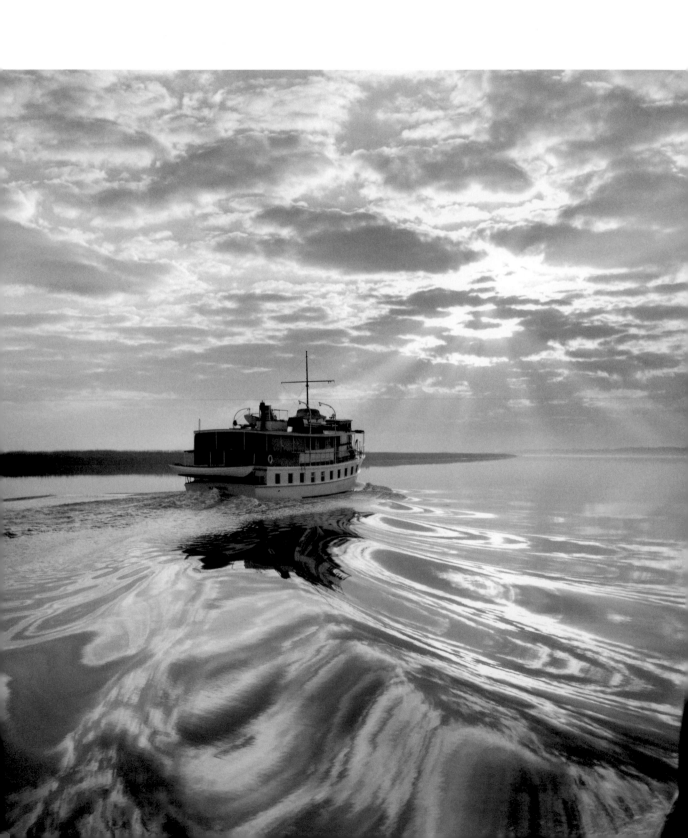

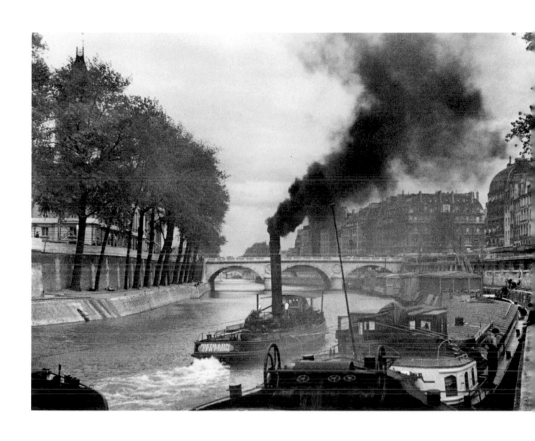

IF A MAN MUST BE OBSESSED BY SOMETHING, I SUPPOSE A BOAT IS AS GOOD AS ANYTHING, perhaps a bit better than most. A small sailing craft is not only beautiful, it is seductive and full of strange promise and the hint of trouble. E. B. White, "The Sea and the Wind That Blows"

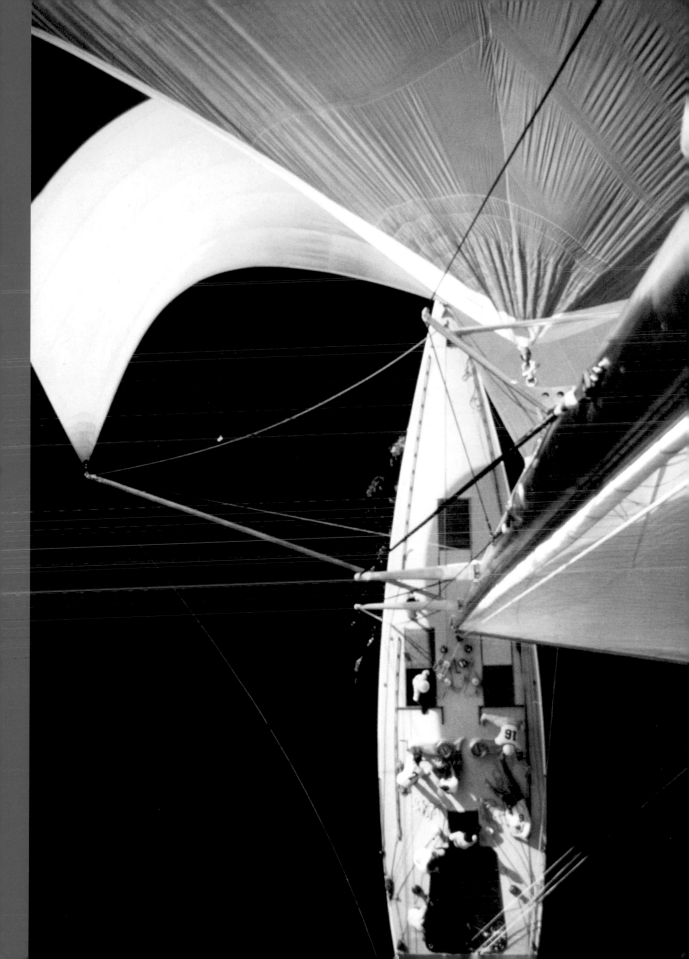

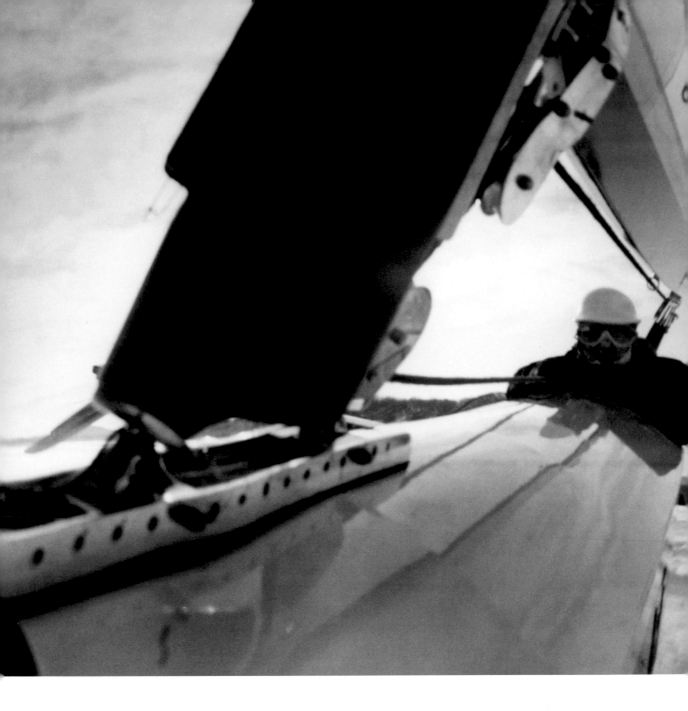

Iceboating, Pewaukee, Wisconsin, 1961 **George Silk**

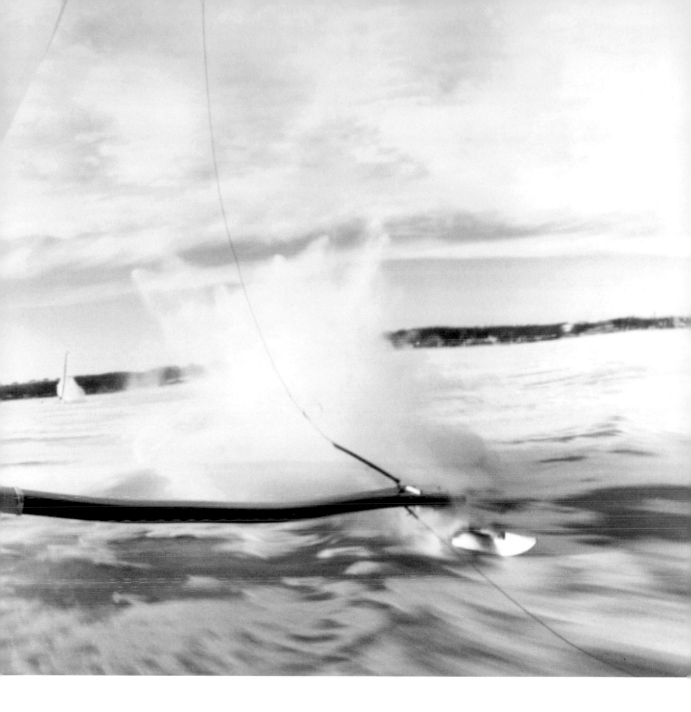

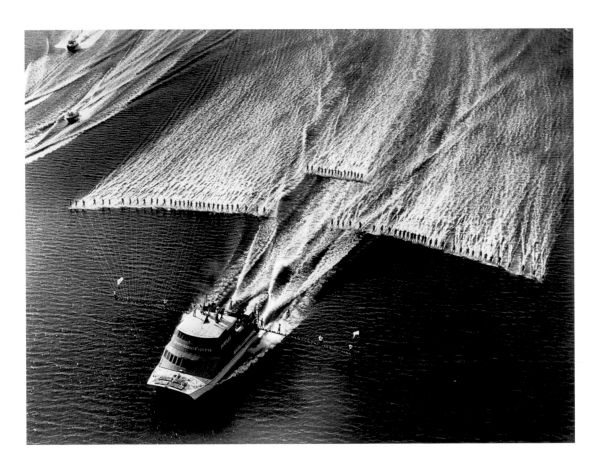

↑ Eighty members of a water-ski-and-powerboat club setting a double ski record by remaining perpendicular
 for 1 nautical mile, Queensland, Australia, 1985 **Arthur Mostead**

→ The *Vanitie* in a practice spin, Newport, Rhode Island, 1934 **Margaret Bourke-White**

OVERLEAF Nuclear submarine *George Washington,* equipped with Polaris missiles on a shakedown cruise
from its base in Holy Loch, Scotland, 1963 **Paul Schutzer**

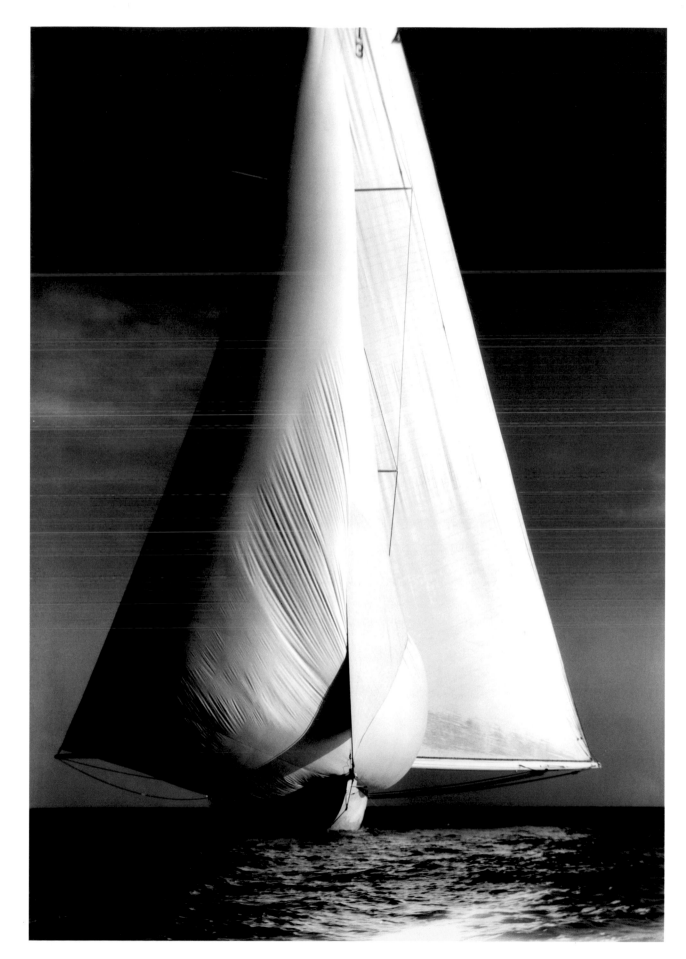

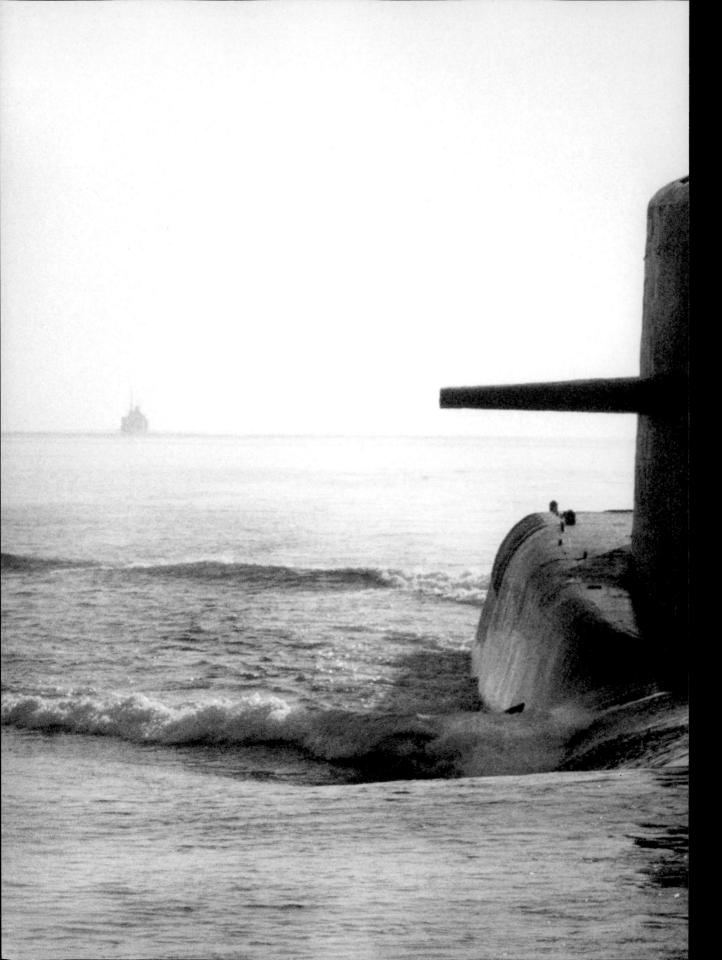

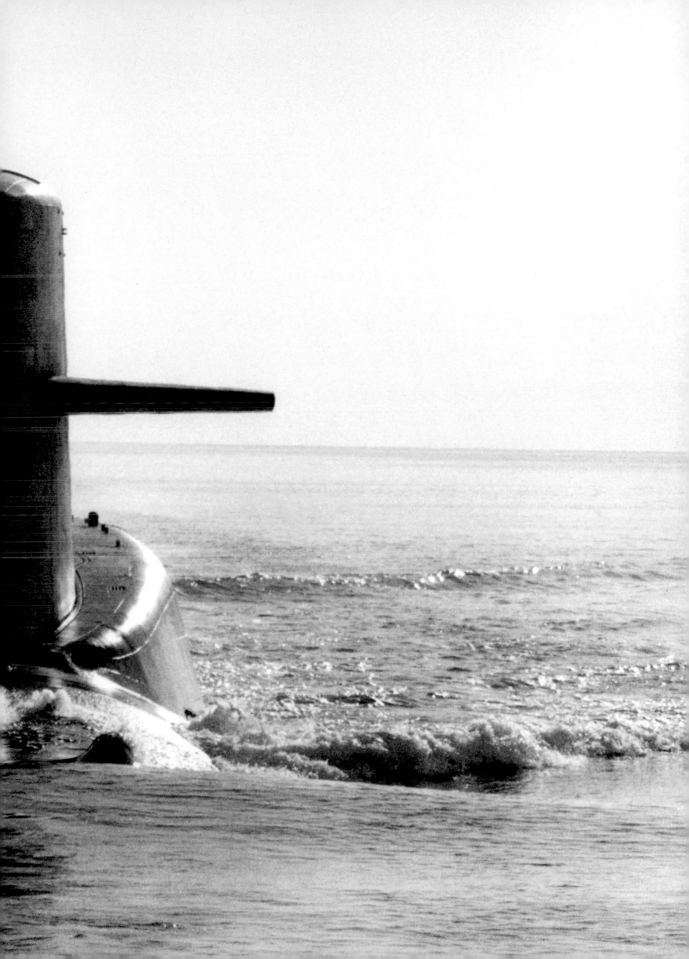

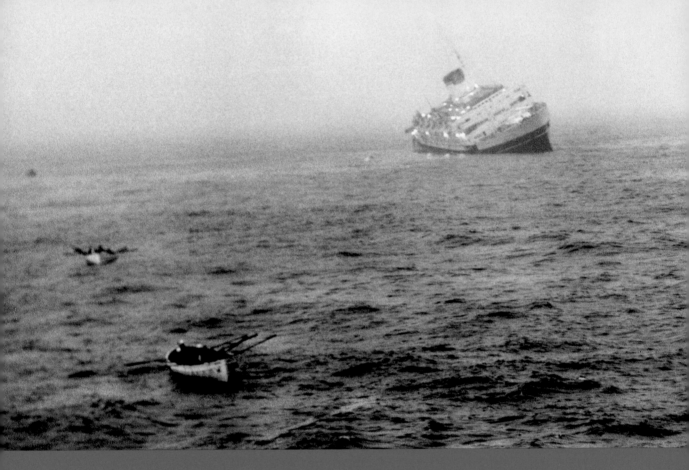

ON THE BRIDGE, SOME MEASURE OF RELIEF WAS FELT. UTTER CATASTROPHE HAD BEEN AVOIDED.

The ship, the pride of Italy, which had seemed about to capsize immediately after the collision, was remaining afloat after all, heroically struggling against death, it seemed, as each minute ticked away. The ship, as shown on the inclinometer, was now hovering at 33 degrees. It was impossible to walk without holding to the guide lines strung across the bridge From the port bridge wing, Captain Calamai could see the high side of the ship emptying, and from the starboard wing he watched the progress of the little dark figures, each a person, climbing over the side and down to the boats.

Alvin Moscow, *Collision Course: The* Andrea Doria *and the* Stockholm

↑ Sinking of the *Andrea Doria,* off Nantucket, Massachusetts, 1956 **Loomis Dean**

→ Hurricane in the Atlantic, photographed from the *Queen Elizabeth*, 1948 **Alfred Eisenstaedt**

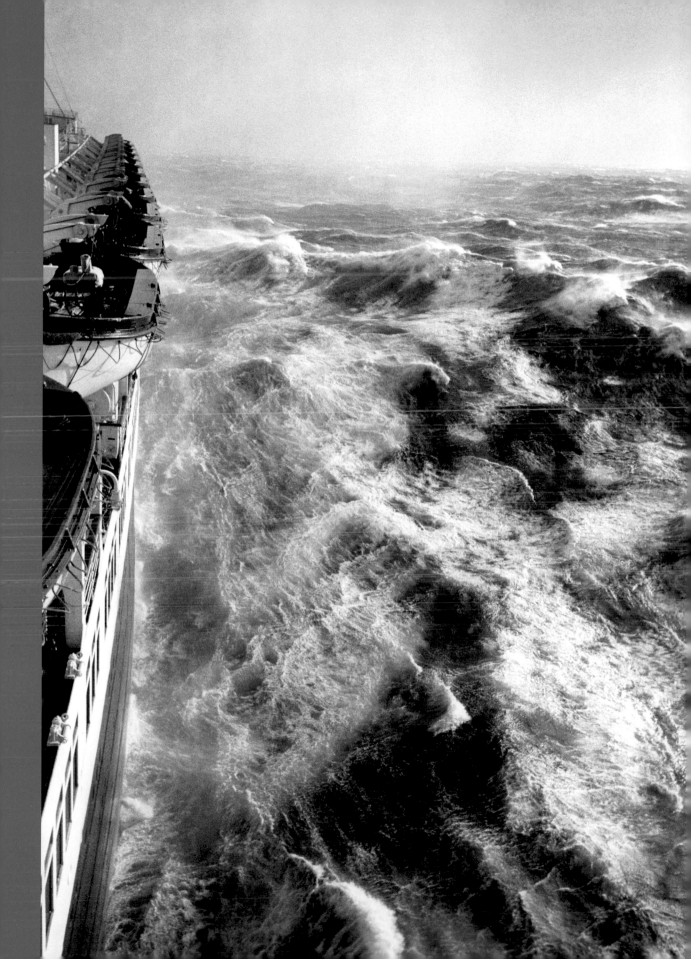

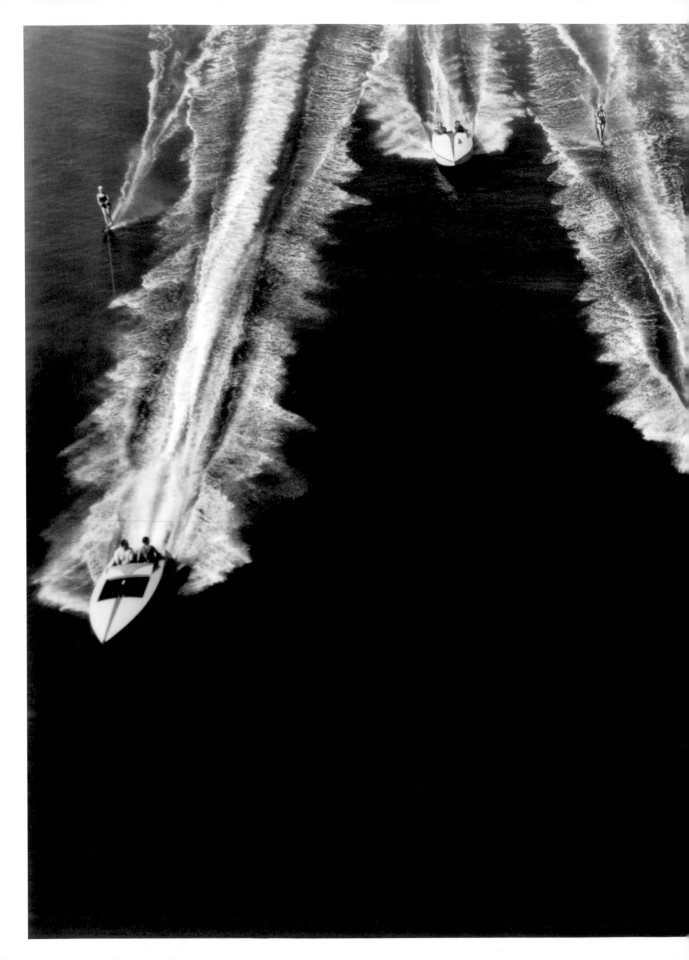

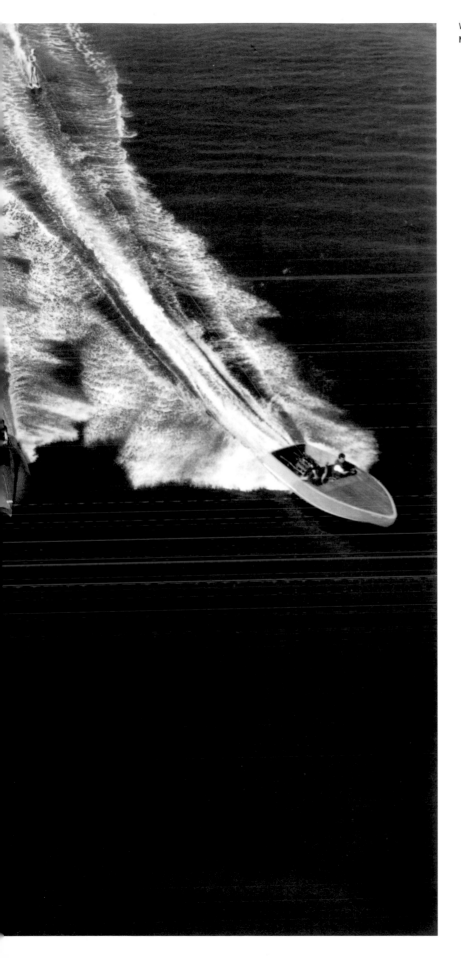

Water-skiers, Long Beach, California, 1951
Margaret Bourke-White

IT HAS BEEN SAID THAT FLYING IS AN ART,
LIKE WRITING OR MAKING LOVE.
If you can't do it nobody will ever teach you, and if you can nobody will ever stop you. But about the art of flying there is at least one notable difference: the writer and lover can try and try again; the aviator must master his technique in the few weeks when the instructor is beside him to prevent a mistake from costing him his life.

Sir Francis Chichester, *Solo to Sydney*

Fledgling pilot of the Women's Flying Training Command alone in her PT-19 army trainer, Avenger Field, Texas, 1943 **Peter Stackpole**

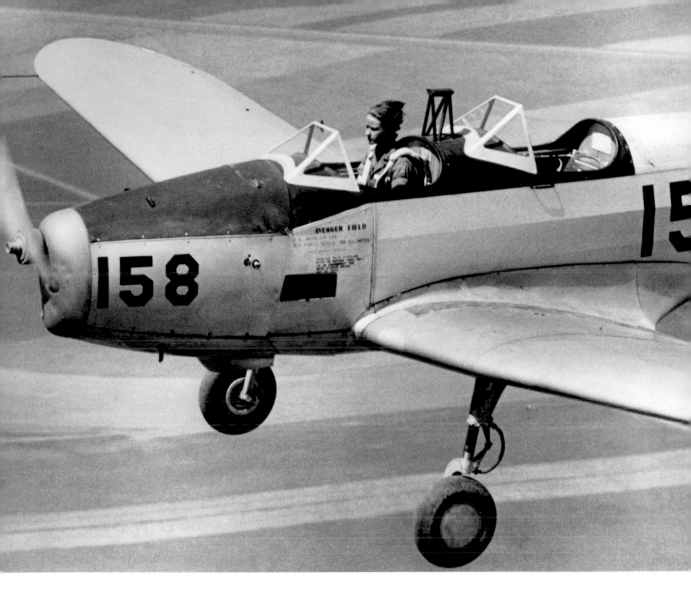

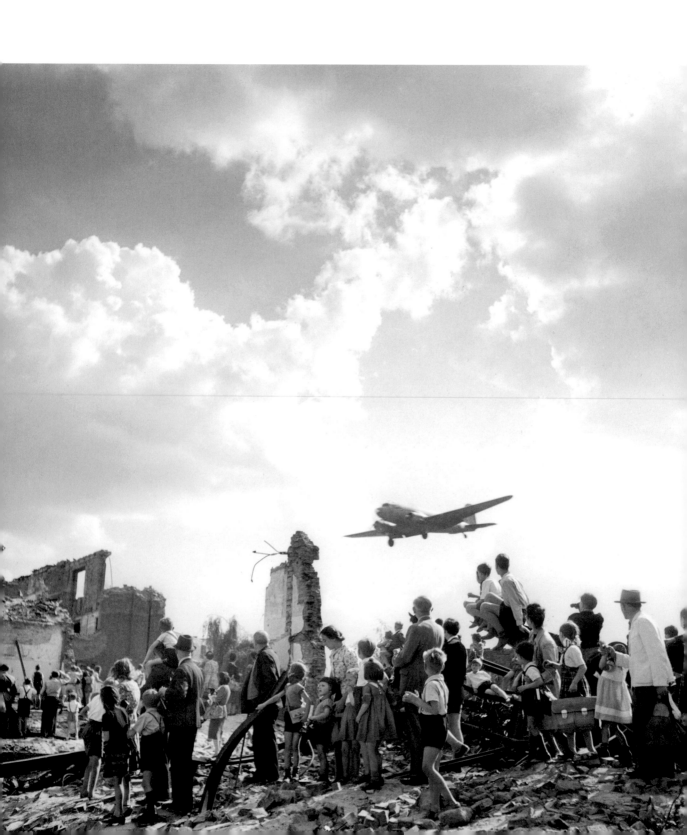

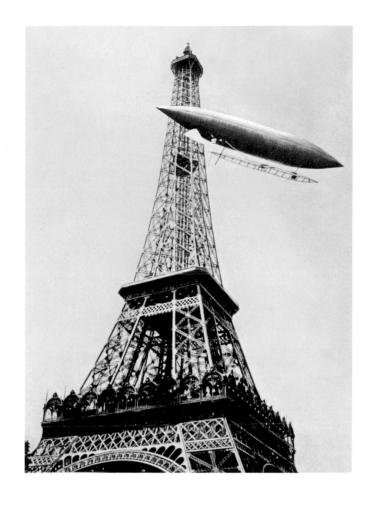

← American C-47 ferrying food and fuel to West Berliners, 1948 **Walter Sanders**

↑ Santos Dumont airship and Eiffel Tower, 1901 **Mansell Collection**

↓ Ground crew of the *Bermuda Clipper*, 1937 **Margaret Bourke-White**

→ Parachute testing, Irving Air Chute Co., Buffalo, New York, 1937 **Margaret Bourke-White**

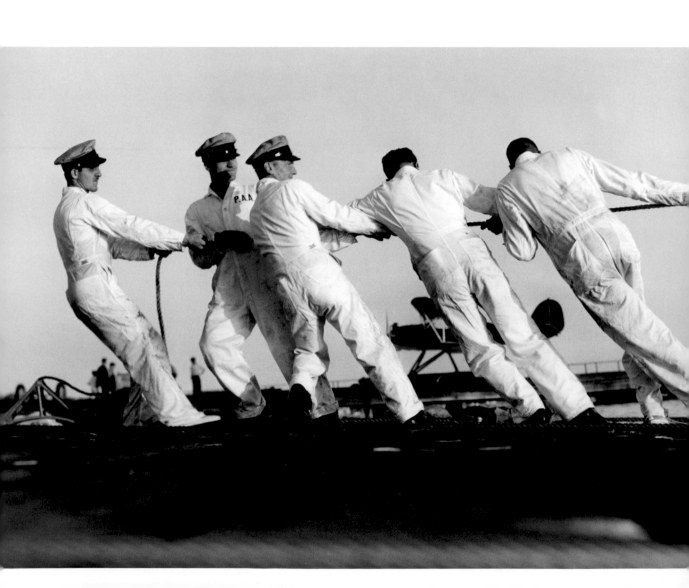

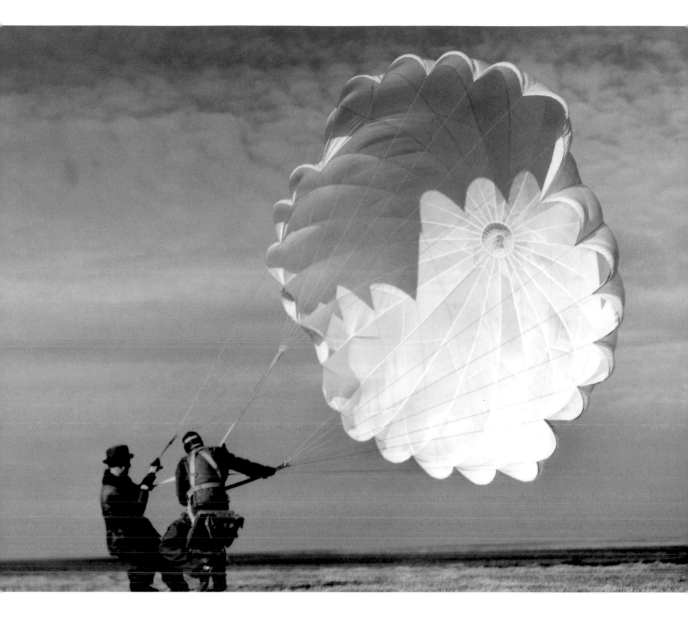

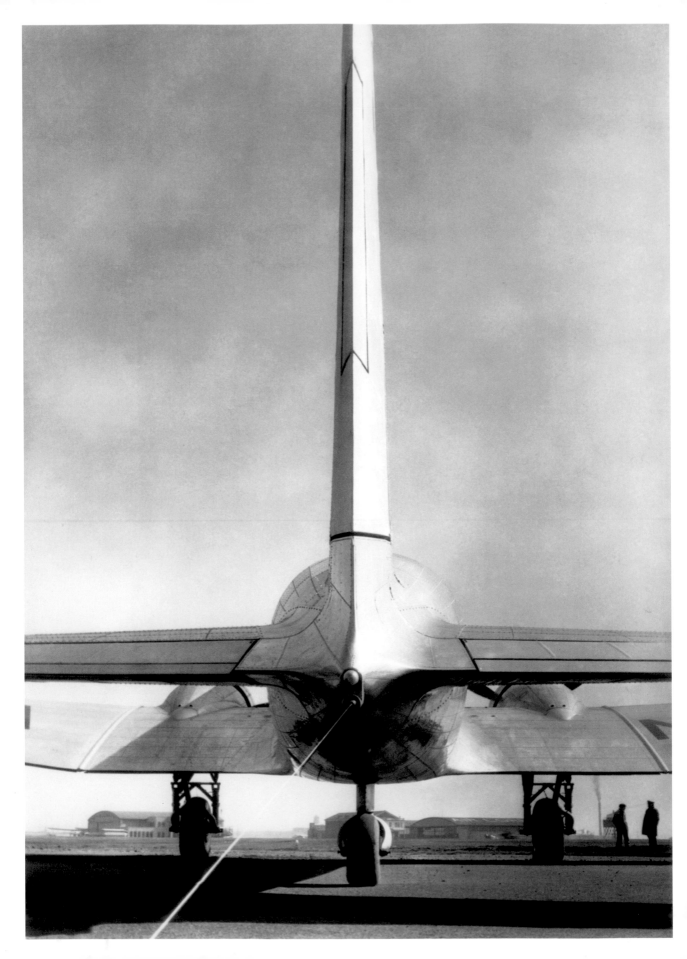

Mr. Nash announced, somewhere between the lobster and the fried sole, that he was going to Munich the next day and was planning to fly from Paris to Strasbourg. Mrs. Hemingway pondered this until the appearance of the rognons sautés aux champignons, when she asked,

'WHY DON'T WE EVER FLY ANYWHERE? WHY IS EVERYBODY ELSE ALWAYS FLYING AND WE'RE ALWAYS STAYING HOME?"

That being one of those questions that cannot be answered by words, I went with Mr. Nash to the office of the Franco-Rumanian Aero Company and bought two tickets, half price for journalists, for 120 francs, good for one flight from Paris to Strasbourg. The trip is ten hours and a half by best express train, and takes two hours and a half by plane. Ernest Hemingway, "A Paris-to-Strasbourg Flight"

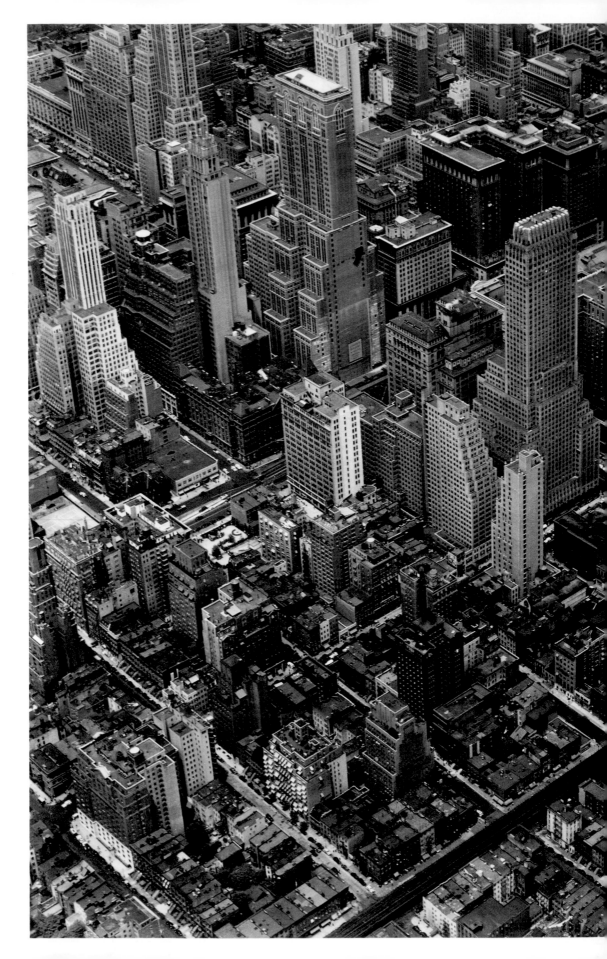

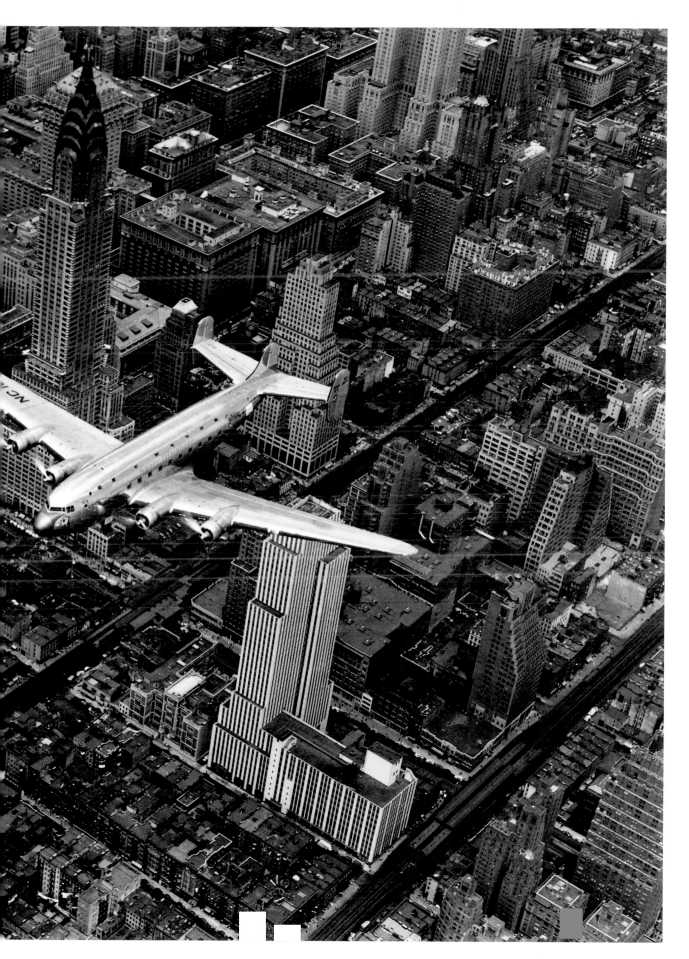

↓ Igor Sikorsky at the controls of his original VS-300 helicopter, Stratford, Connecticut, 1940. Sikorsky always wore his fedora when flying. **Sikorsky Aircraft Corporation**

→ The 187th Airborne Regimental Combat Team jumping into North Korea, 1950 **Howard Sochurek**

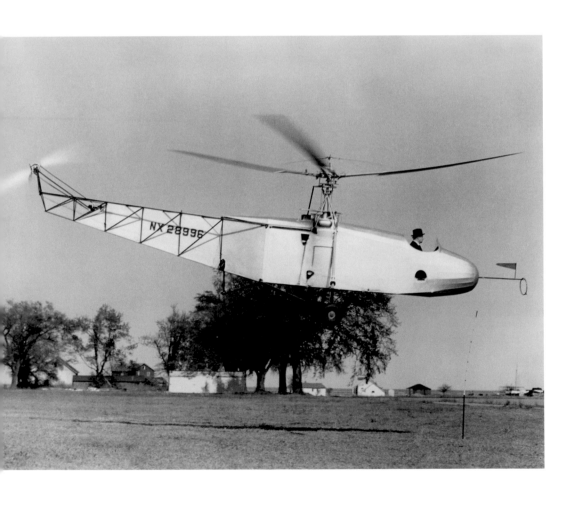

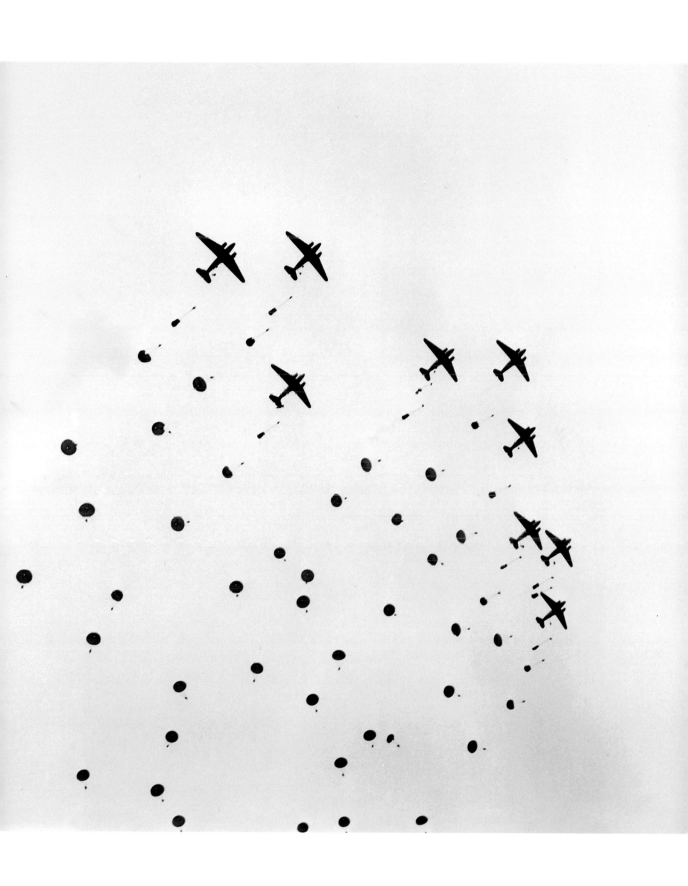

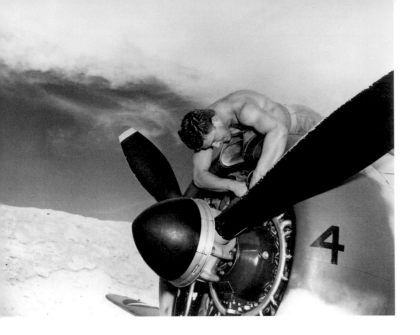

↑ Adjusting an engine at the U.S. Marine base at Midway, in the Pacific, 1942 **Frank Scherschel**

↓ Navy planes aboard the aircraft carrier *Boxer*, San Diego, California, 1951 **Margaret Bourke-White**

→ U.S. dive-bombers on patrol near Midway Island, 1942 **Frank Scherschel**

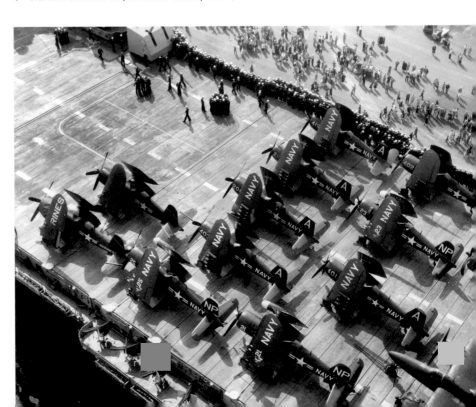

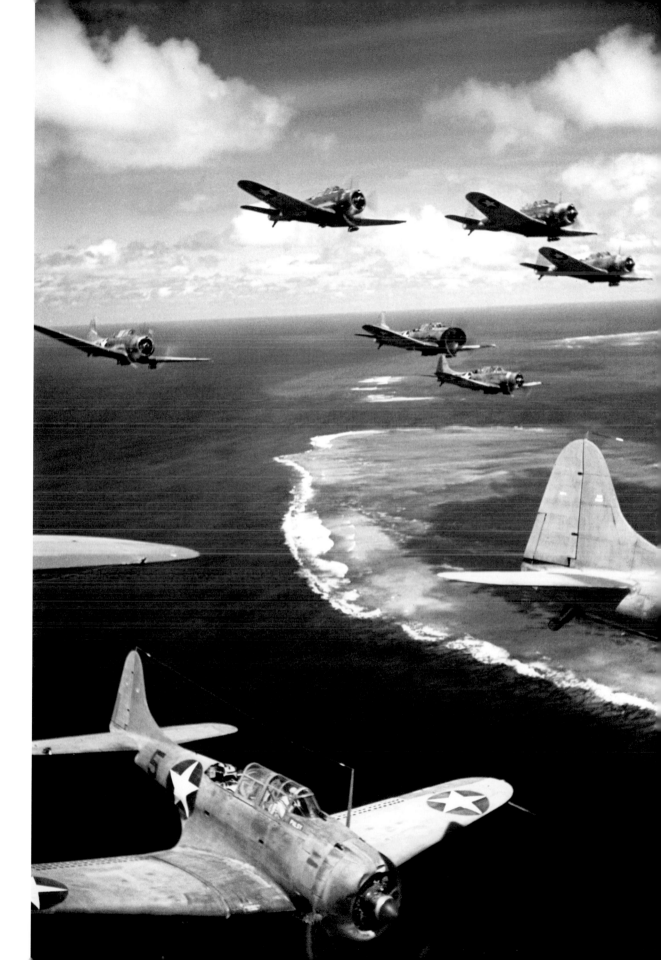

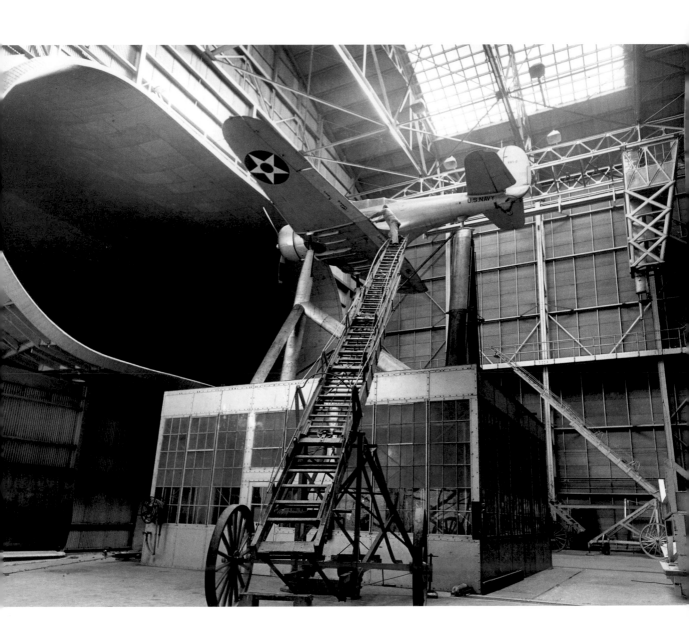

HAVE YOU LOOKED AT A MODERN AIRPLANE ?

Have you followed from year to year the evolution of its lines? Have you ever thought, not only about the airplane but about whatever man builds, that all of man's industrial efforts, all his computations and calculations, all the nights spent over working draughts and blueprints, invariably culminate in the production of a thing whose sole and guiding principle is the ultimate principle of simplicity?

Antoine de Saint-Exupéry, *Airman's Odyssey*

Test model of a plane undergoing airflow measurements, Langley Field, Virginia, 1941 **Carl Mydans**

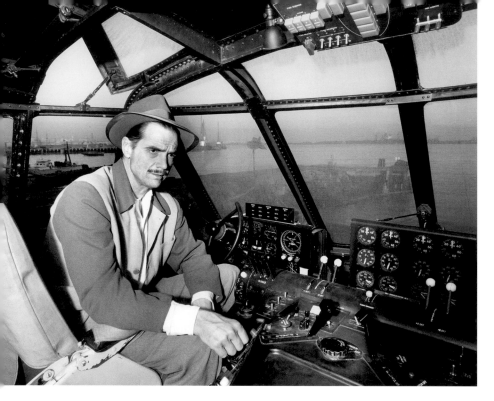

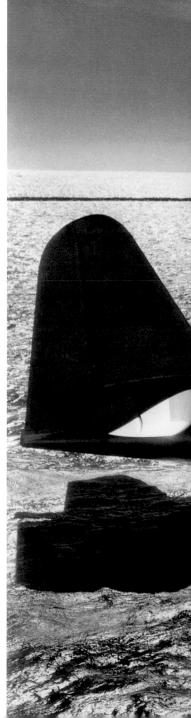

↑ Howard Hughes at the controls of his 200-ton wooden flying boat, nicknamed *Spruce Goose*,
 Los Angeles, 1947 **J. R. Eyerman**

→ Howard Hughes's *Spruce Goose*, 1947 **J. R. Eyerman**

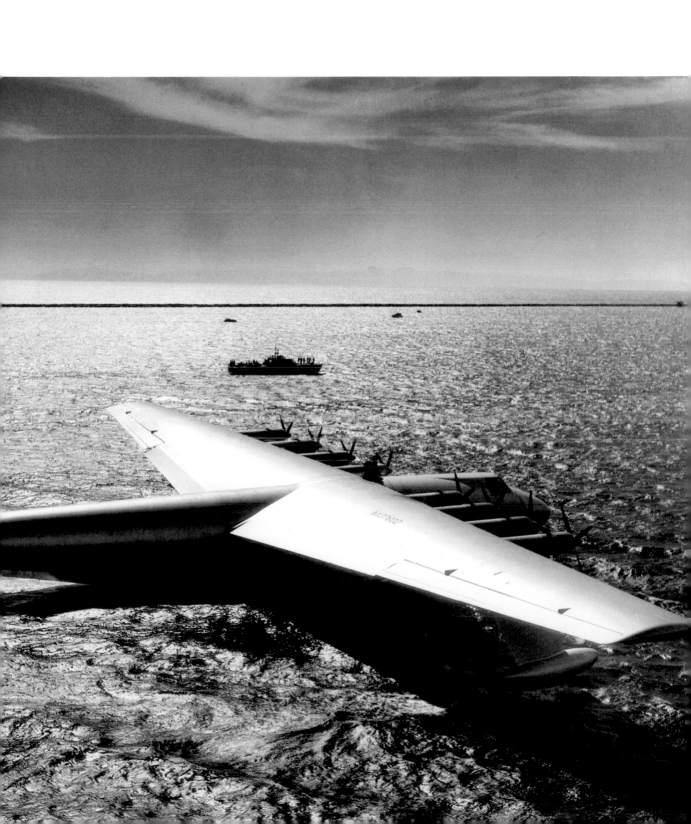

[A]nd yet it was beautiful, exhilarating! — for he was revved up with adrenalin, anxious to take off before the day broke,

TO BURST UP
INTO THE SUNLIGHT
OVER THE RIDGES
BEFORE ALL THOSE THOUSANDS OF COMATOSE SOULS DOWN THERE,

still dead to the world, snug in home and hearth, even came to their senses. To take off in an F-100 at dawn and cut in the afterburner and hurtle twenty-five thousand feet up into the sky so suddenly that you felt not like a bird but like a trajectory, yet with full control, full control of *five tons* of thrust, all of which flowed from your will and through your fingertips, with the huge engine right beneath you, so close that it was as if you were riding it bareback, until you leveled out and went supersonic, an event registered on earth by a tremendous cracking boom that shook windows, but up here only by the fact that you now felt utterly free of the earth.

Tom Wolfe, *The Right Stuff*

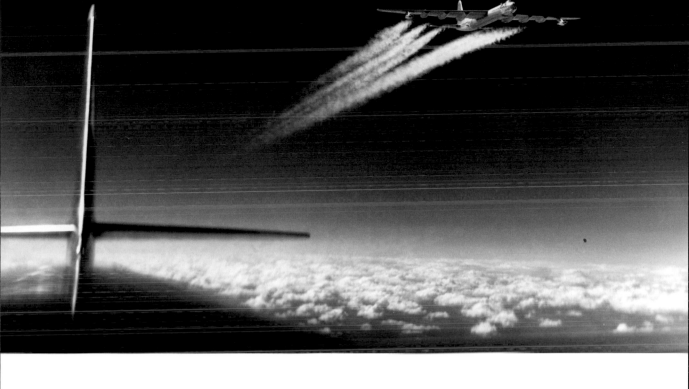

B-36 streaks over Wichita, Kansas, at 41,000 feet, 1951 **Margaret Bourke-White**

OVERLEAF (L) Los Angeles motorcycle police during full-scale inspection at the Coliseum, 1949 **Loomis Dean**

OVERLEAF (R) Air fair, Los Angeles, 1956 **Loomis Dean**

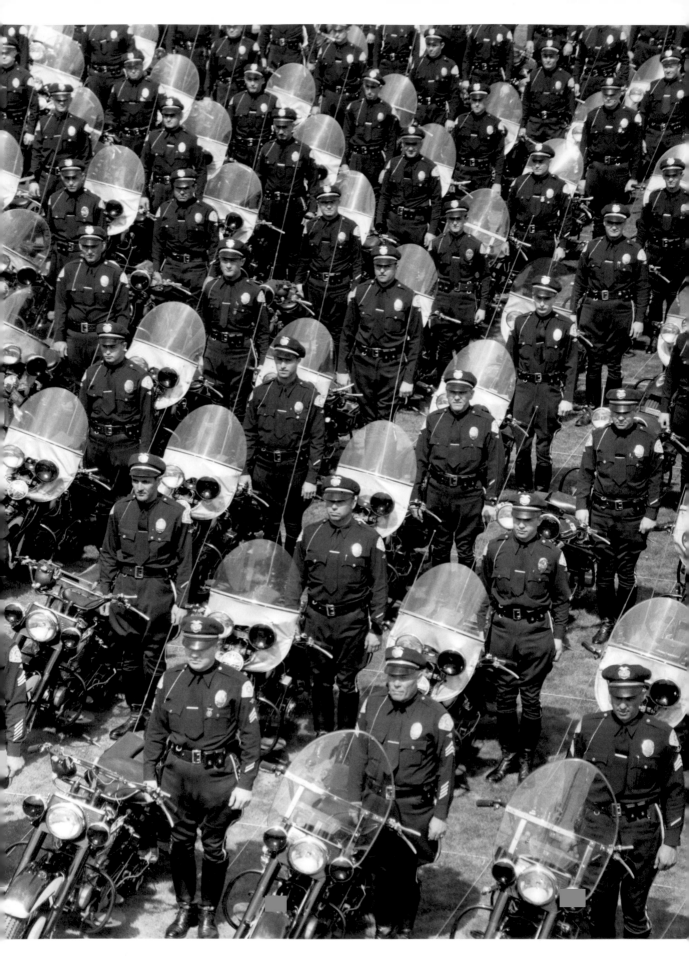

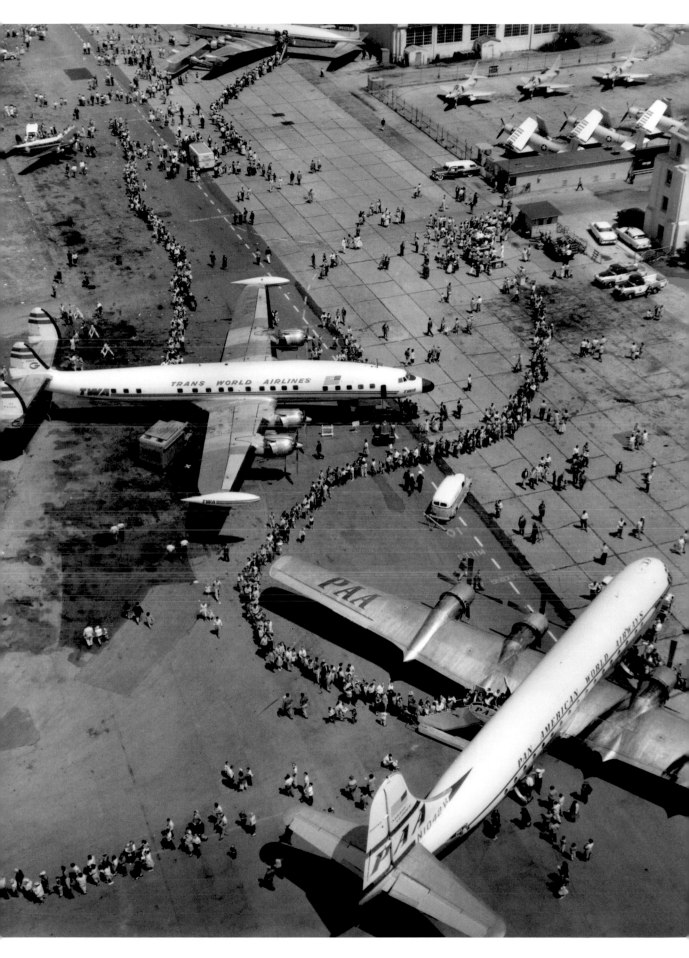

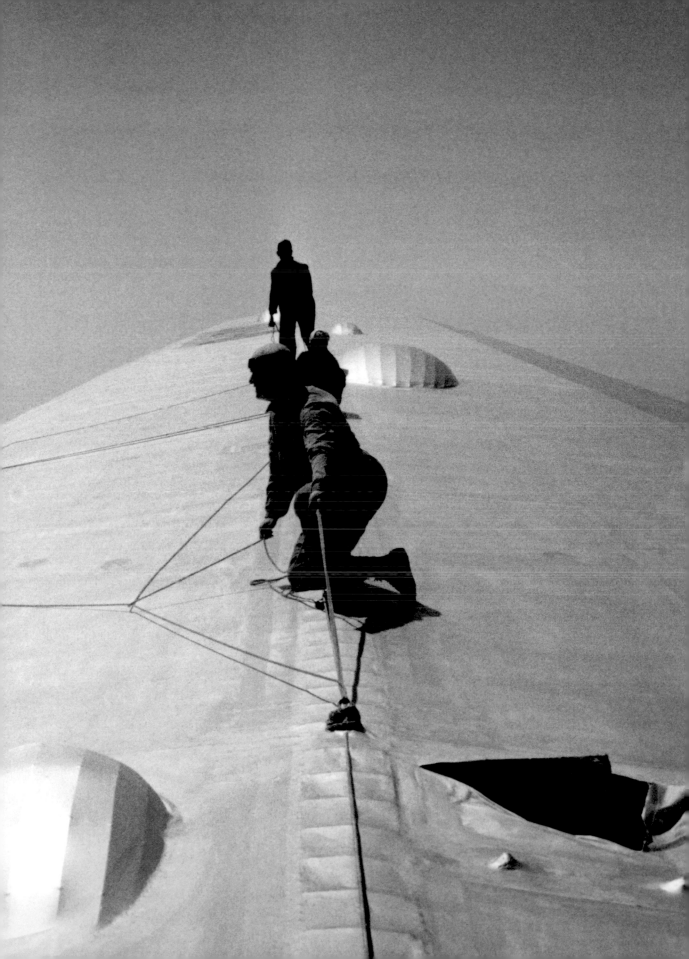

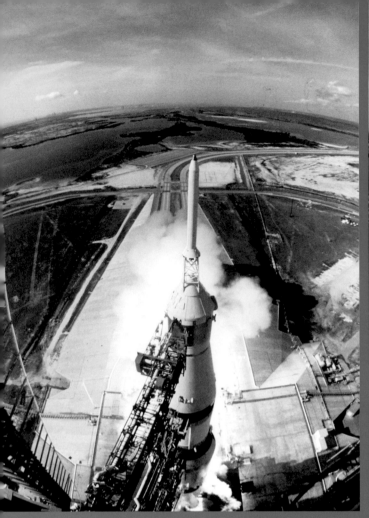
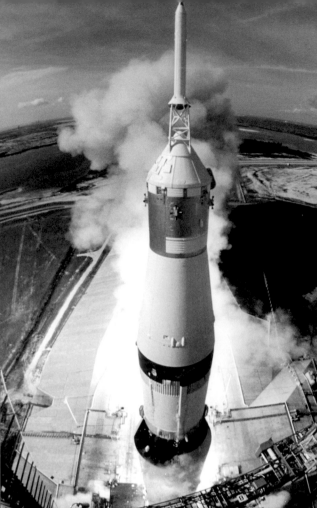

" . . . ALL ENGINES RUNNING.
LIFT-OFF!"

NASA Launch Control

The launch of *Apollo 11* to the moon, July 16, 1969 **Ralph Morse**

PREVIOUS SPREAD Repairing the hull of the *Graf Zeppelin* during its flight over the Atlantic, 1934 **Alfred Eisenstaedt**

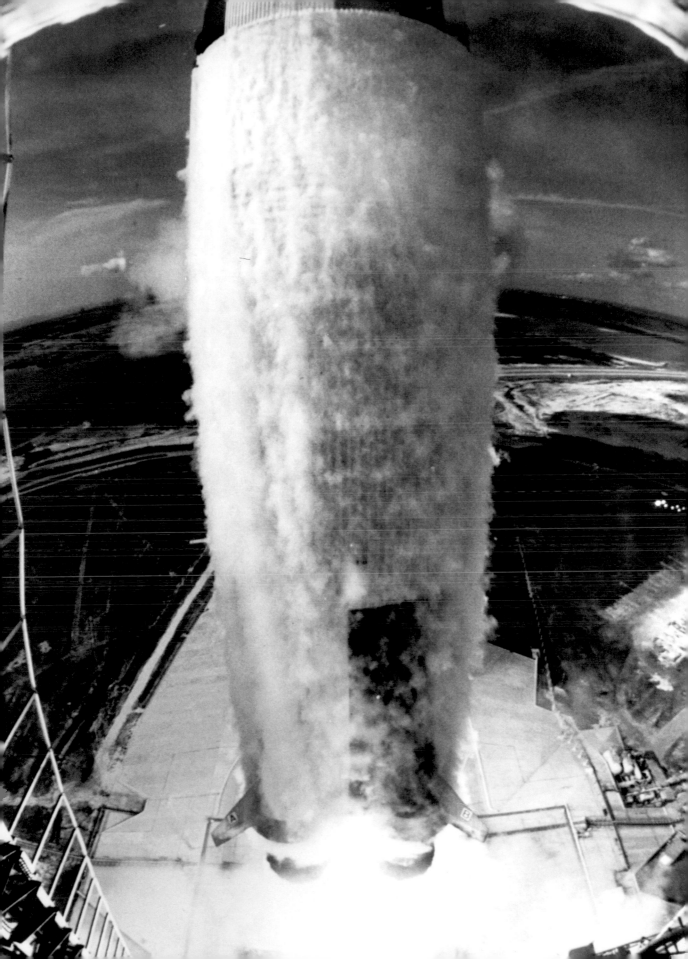

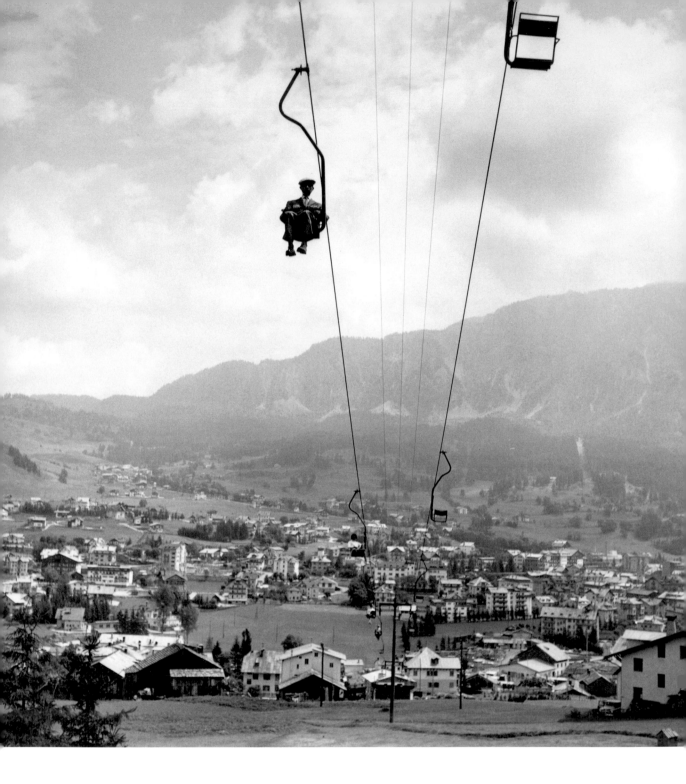

↑ A summer passenger on a ski lift high above the town of Cortina, Italy, 1955 **Jerry Cooke**

→ Attaching the basket to a Goodyear balloon, Akron, Ohio, 1940 **John Phillips**

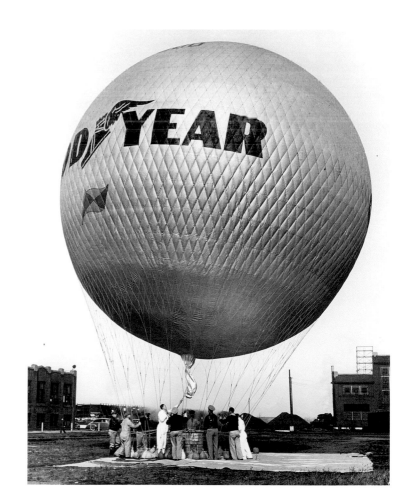

Cloud in Nova Scotia, Canada, 1979 **John Loengard**

OVERLEAF Marketplace in New Orleans, Louisiana, 1936 **Carl Mydans**

WHAT IS THAT FEELING WHEN YOU'RE DRIVING AWAY
from people and they recede on the plain till you see their specks dispersing? –
it's the too-huge world vaulting us, and it's good-by. But we lean forward to the next
crazy venture beneath the skies. Jack Kerouac, *On the Road*

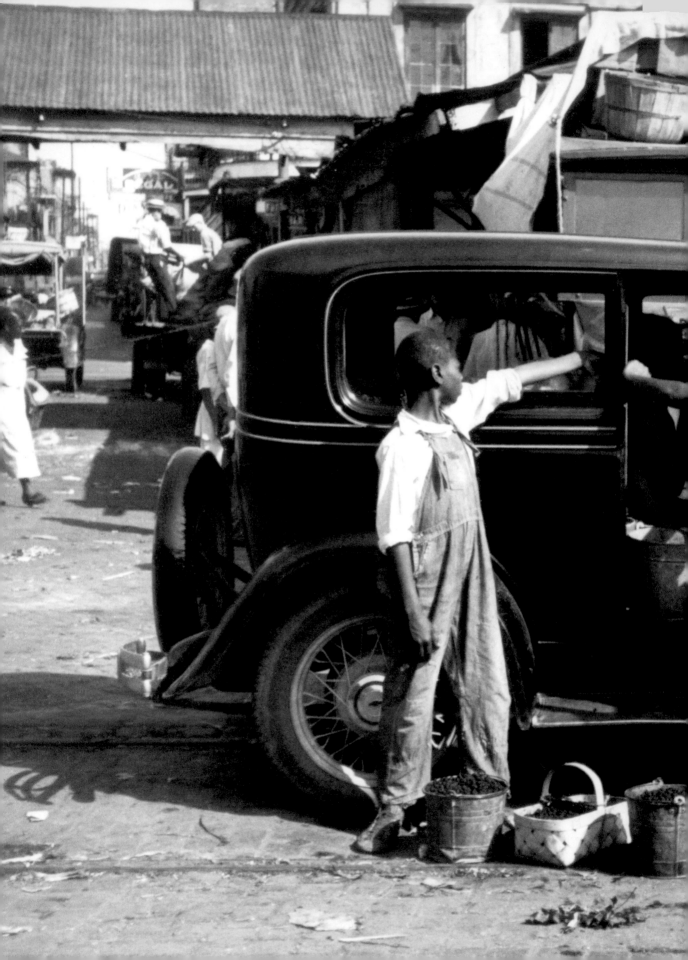

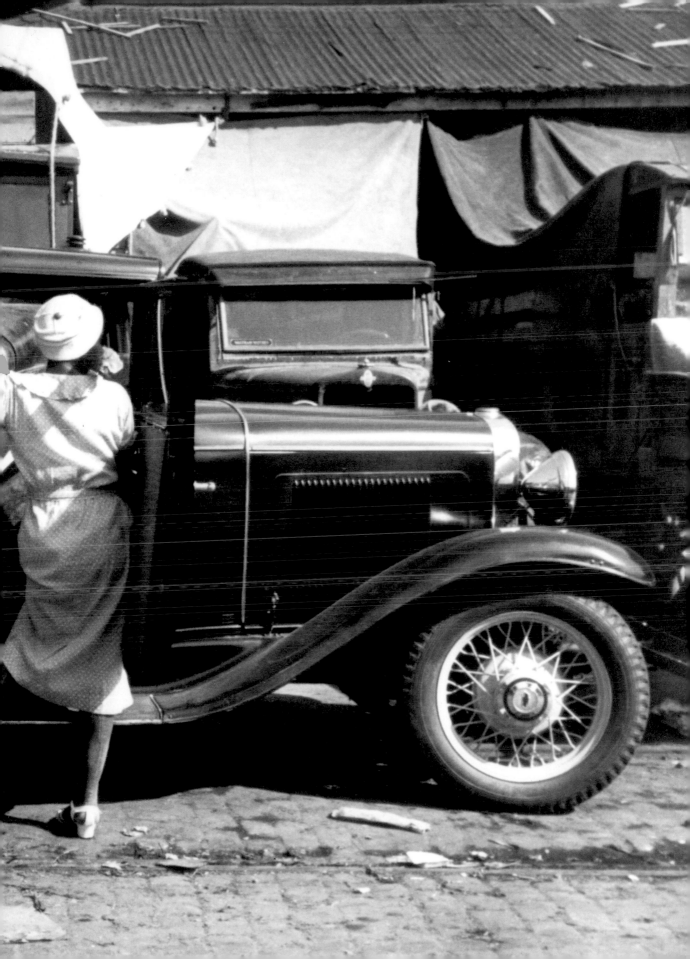

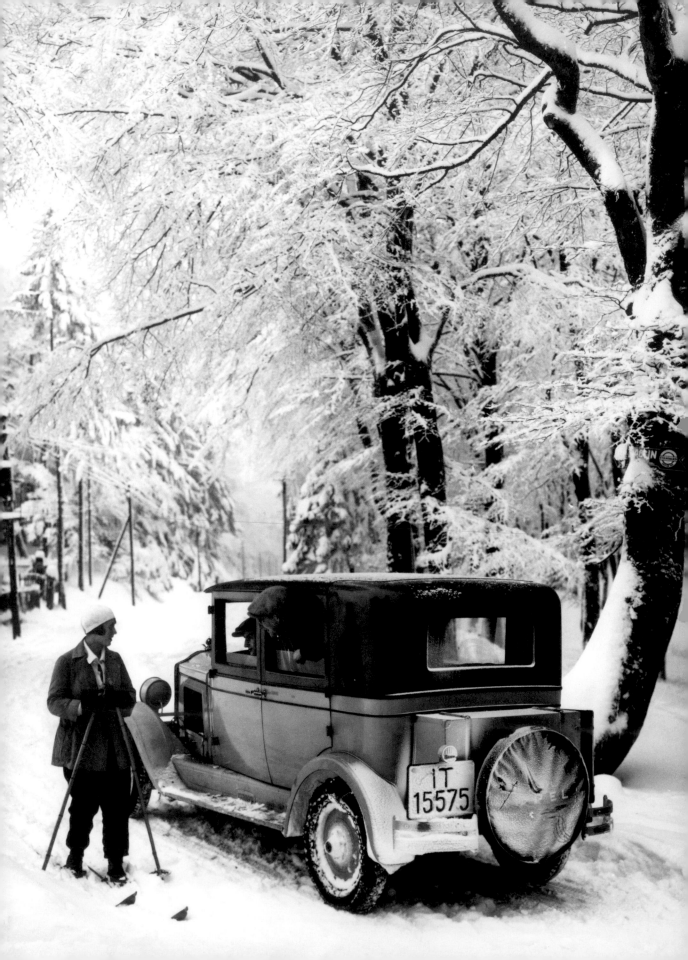

HE SAW ME LOOKING WITH ADMIRATION AT HIS CAR.

"It's pretty, isn't it, old sport." He jumped off to give me a better view. "Haven't you ever seen it before?" I'd seen it. Everybody had seen it. It was a rich cream color, bright with nickel, swollen here and there in its monstrous length with triumphant hatboxes and supper-boxes and tool-boxes, and terraced with a labyrinth of windshields that mirrored a dozen suns. Sitting down behind many layers of glass in a sort of green leather conservatory we started to town.

F. Scott Fitzgerald, *The Great Gatsby*

President Roosevelt's car, a Ford V-8 with hand controls, at the
Warm Springs Foundation, Georgia, 1938 **Margaret Bourke-White**

THE SURGING SIZE AND INCREASED EMPHASIS ON STYLE AND LUXURY in American cars were just one sign of the new abundance of the era. After World War Two most Americans had a vision of a better life just ahead. At the core of it was owning one's own house – and as Henry Ford's invention and a rapidly improving network of roads and highways opened up the vast spaces of farmland surrounding American cities, the vision started to become a reality: Suburbia. Indeed, people knew even what they wanted to pay for their first house: $5,000, which was then roughly equal to an average family's wages for two years If a new car was a critical status symbol, a house was something else. David Halberstam, *The Fifties*

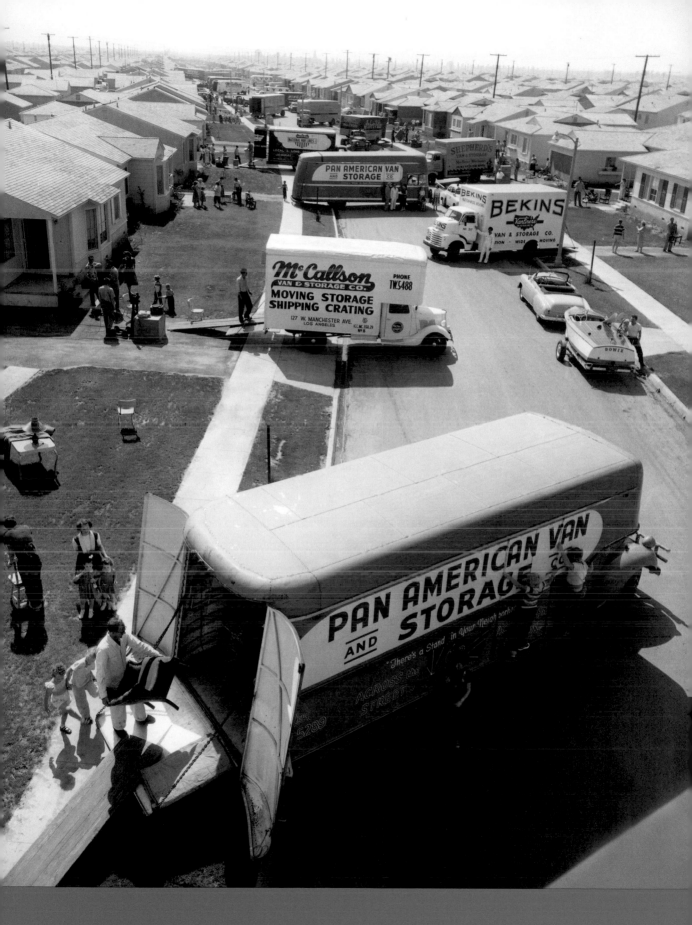

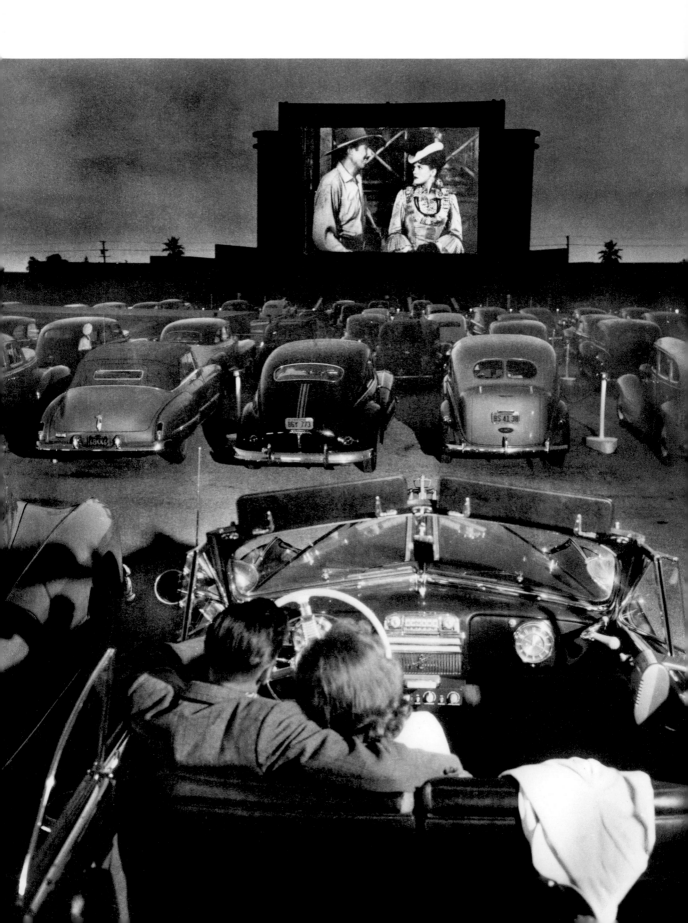

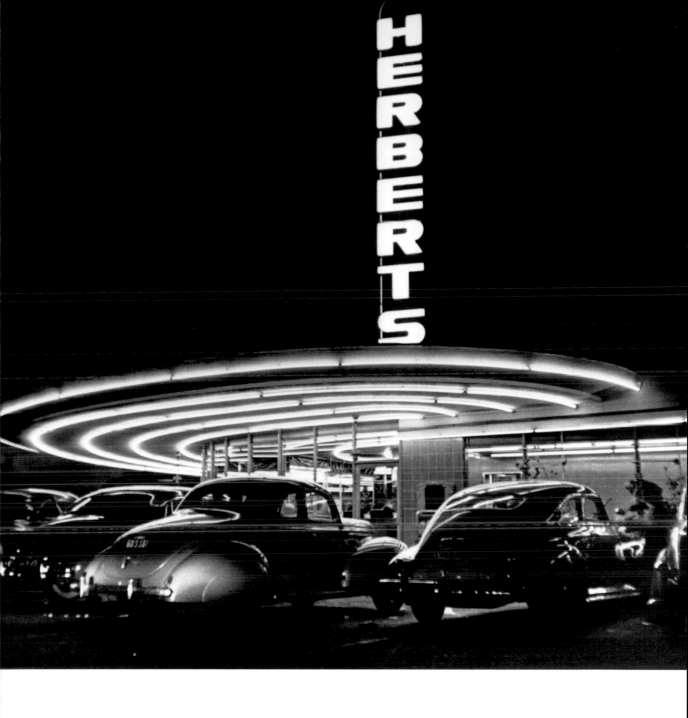

← Drive-in theater, Los Angeles, California, 1949 **J. R. Eyerman**

↑ Drive-in restaurant, West Los Angeles, California, 1945 **Nina Leen**

OVERLEAF Drive-in restaurant, Los Angeles, 1949 **Loomis Dean**

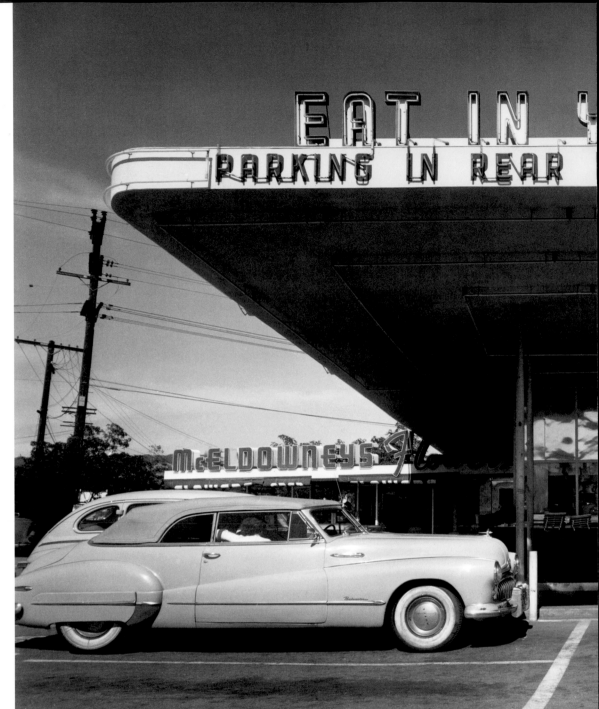

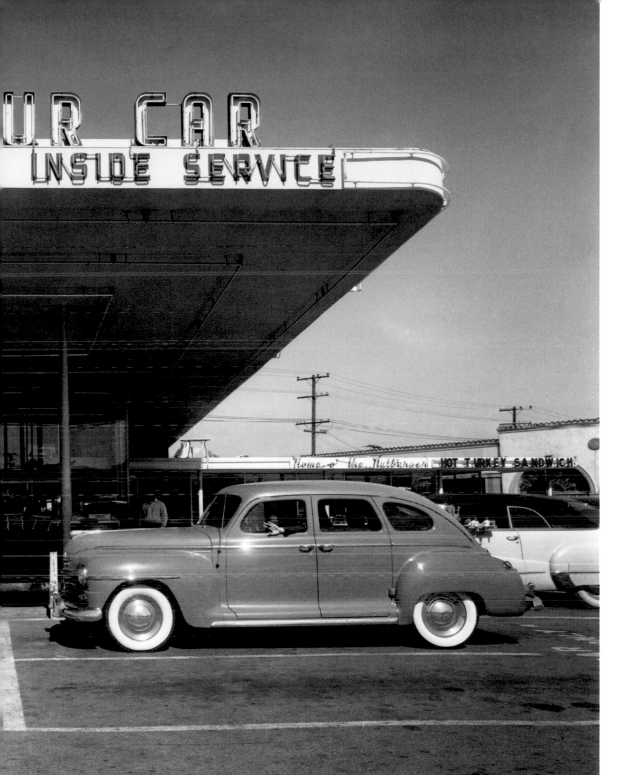

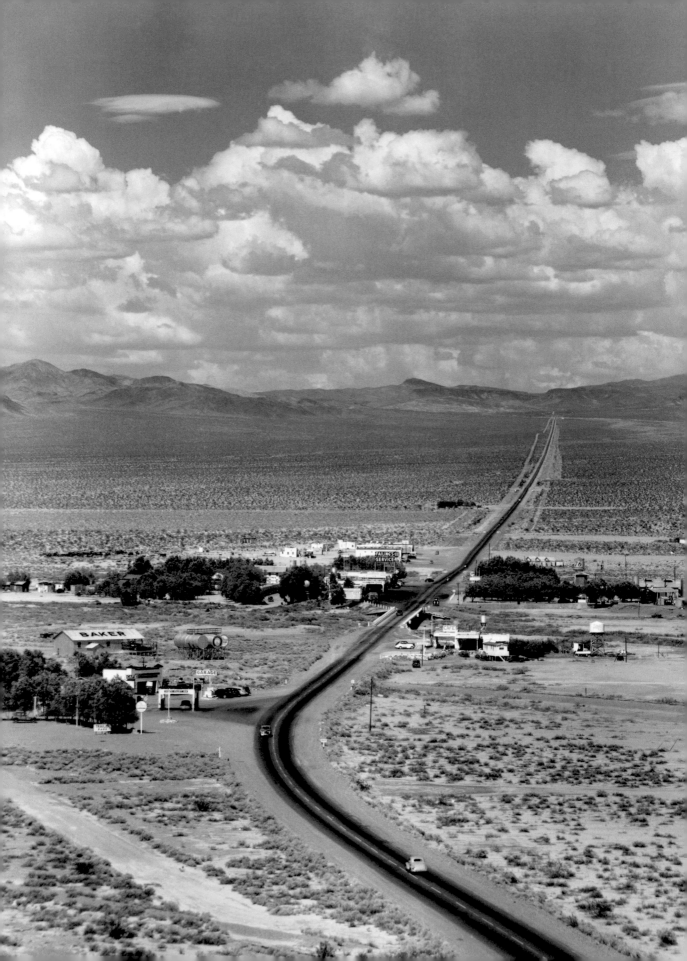

I HAD, IN FACT, BEGUN TO THINK OF THE DESERT ITSELF AS AN OCEAN.

The glint of sunlight on vast and uniform shields of gray-green vegetation is very like its metallic glare from a rolling sea. The mountain ranges stand on the land like archipelagos. Cloud shadows drift slowly across the empty basins or across the flanks of salmon-tinted mountains like huge fish. Occasionally the land becomes so extensive the horizon itself becomes nautical – the edge of the earth seems to curve over into space. **Barry Lopez, "California Desert"**

U.S. 91 crossing the Mojave Desert, Baker, California, 1947 **Andreas Feininger**

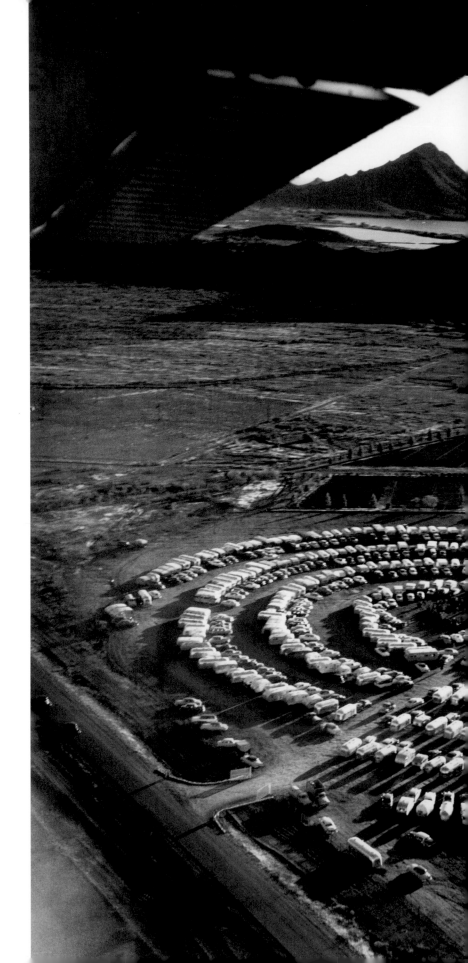

Five hundred American trailers camping
for the night, Guaymas, Mexico, 1955
Loomis Dean

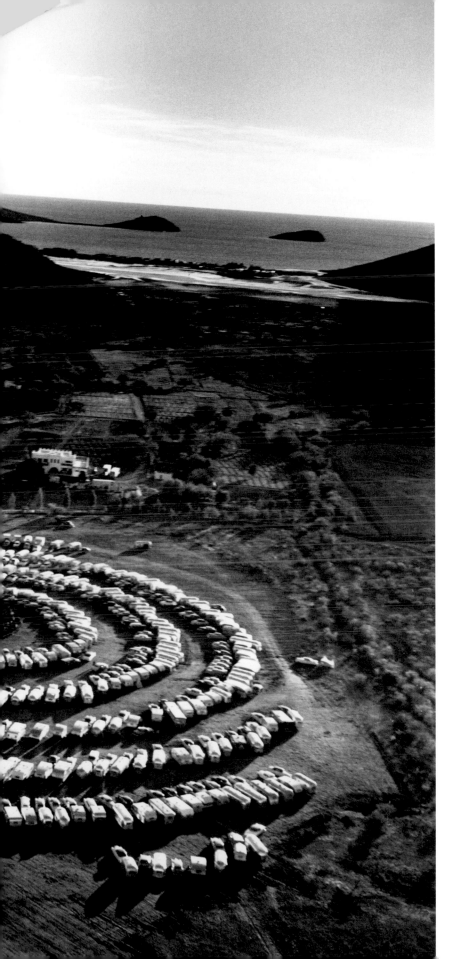

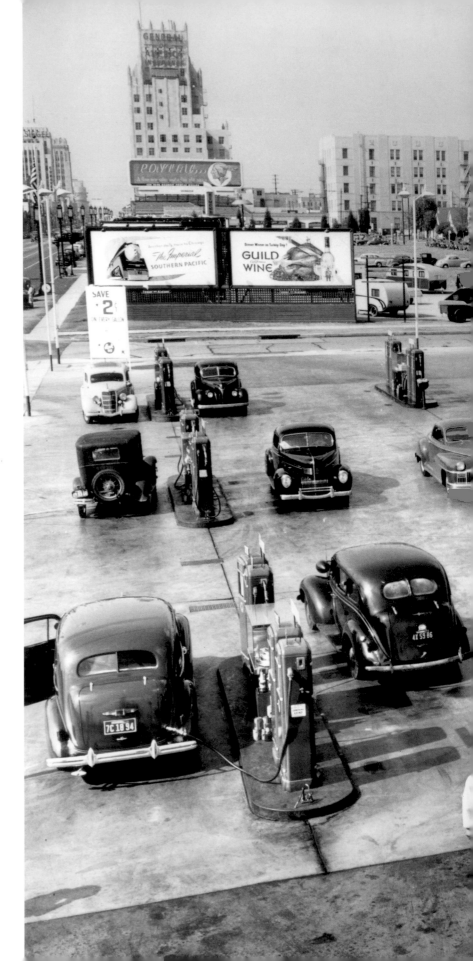

The world's largest gas station, Los Angeles,
California, 1946 **Ralph Crane**

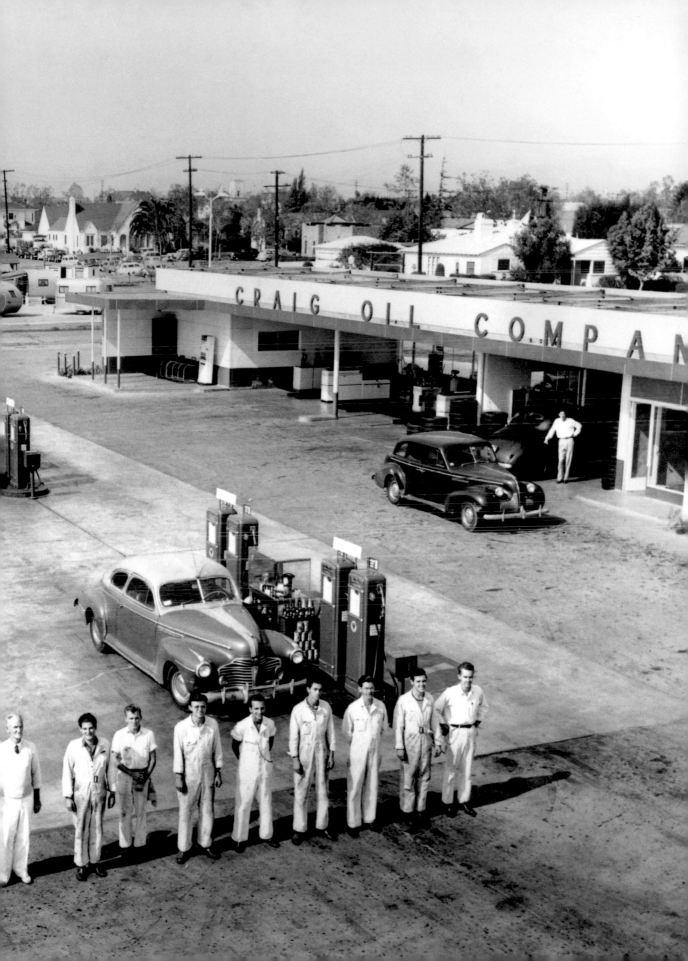

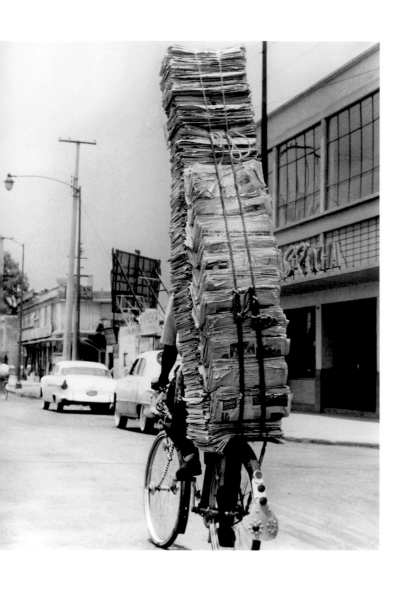

↑ Old newspapers being transported by bicycle, Mexico City, 1959 **Irving Schild**

→ A motorcycling family on Route 30, en route to Cheyenne, Wyoming, from Omaha, Nebraska, 1948 **Allan Grant**

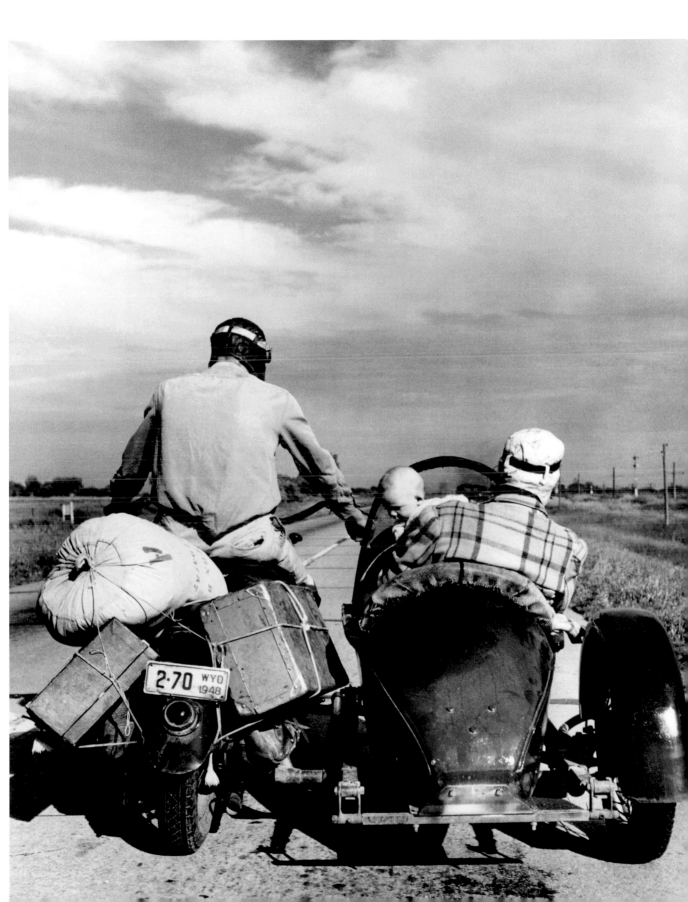

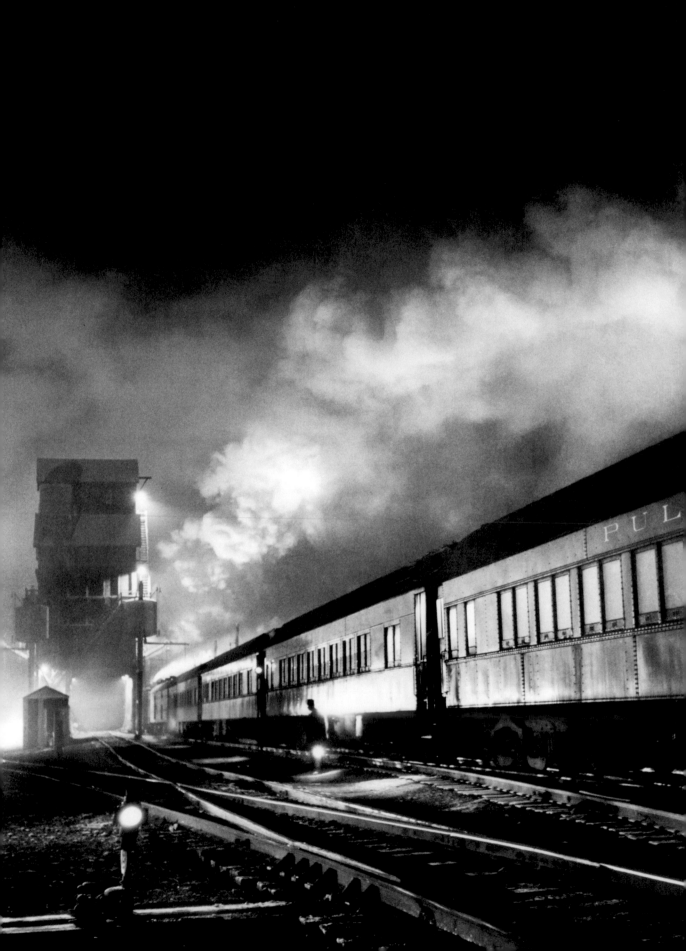

AMERICA IS A FABULOUS COUNTRY....

It is the place of the mile-long freights with their strong, solid, clanking, heavy loneliness at night, and of the silent freight of cars that curve away among raw piney desolations with their promise of new lands and unknown distances — the huge attentive gape of emptiness . . . the place of huge stillness of the water tower, the fading light, the rails, secret and alive, and trembling with the oncoming train **Thomas Wolfe,** *Of Time and the River*

The coaled-up *Golden State Limited* waiting for the "highball" signal in Eldon, Iowa, 1946 **Gordon Coster**

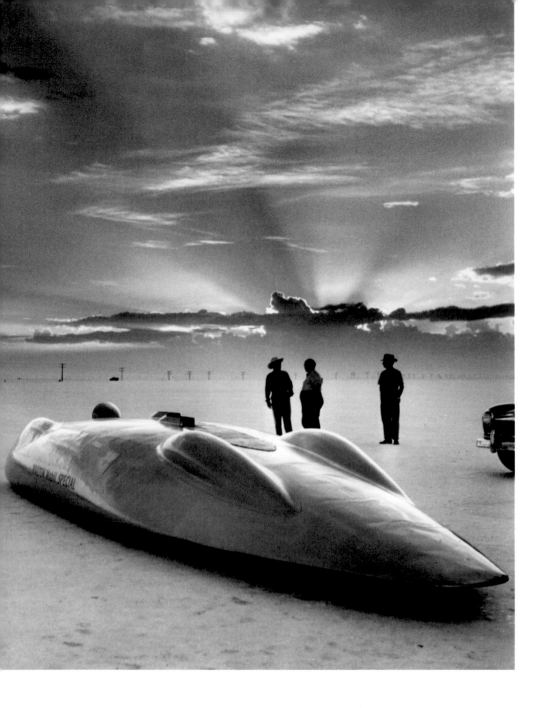

↑ John Cobb's 2,600-horsepower racing car. The 28-foot 8-inch *Railton Special,* powered by two 12-cylinder engines, made a 334-mph trial run at Wendover, Utah, in 1947. **Jon Brenneis**

→ Monorail at the Seattle World's Fair, Seattle, Washington, 1962 **Ralph Crane**

OVERLEAF Black automobiles on the Piazza del Campidoglio during a Fascist celebration of the fourth anniversary of the Italian Empire, Rome, 1940 **Carl Mydans**

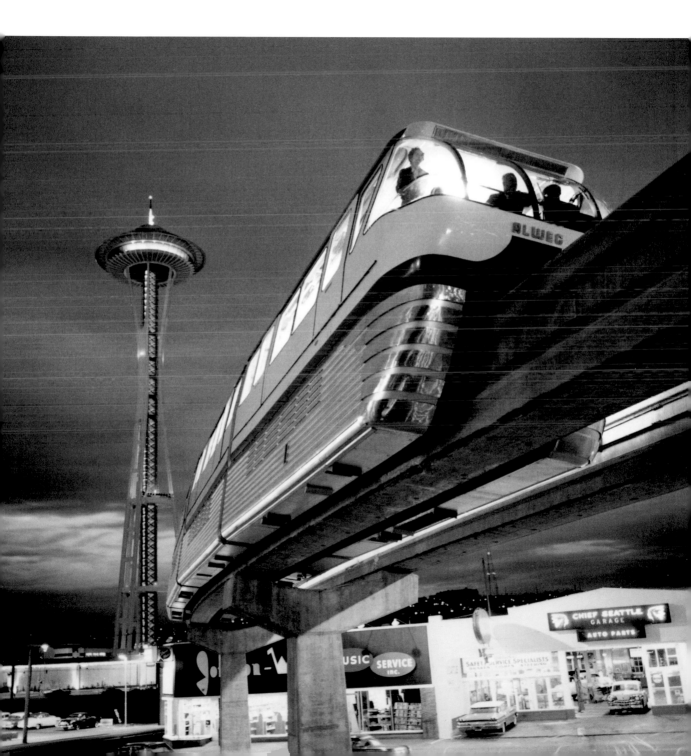

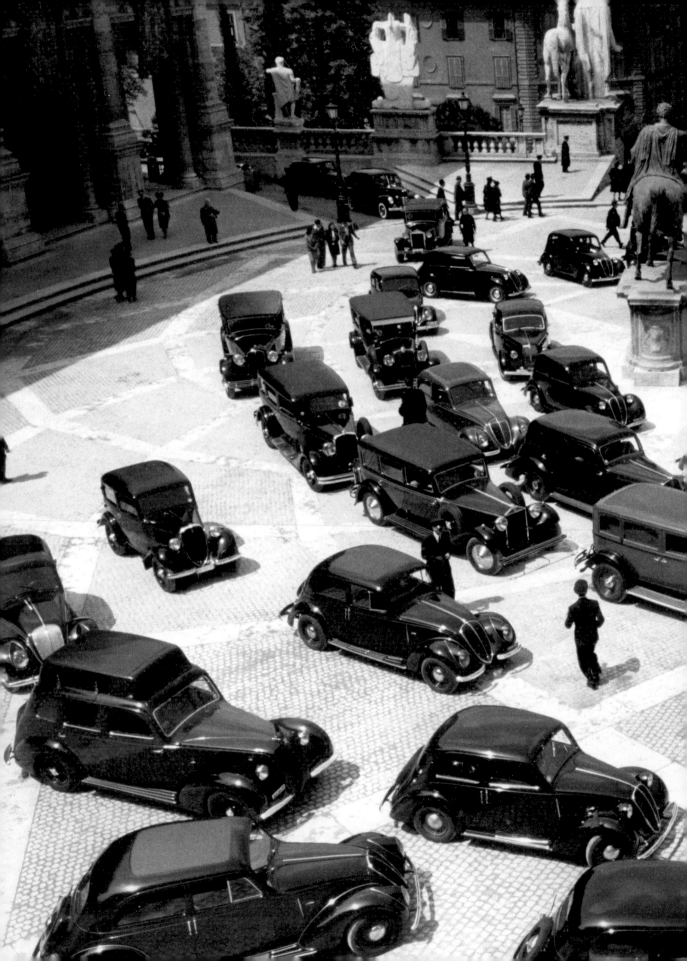

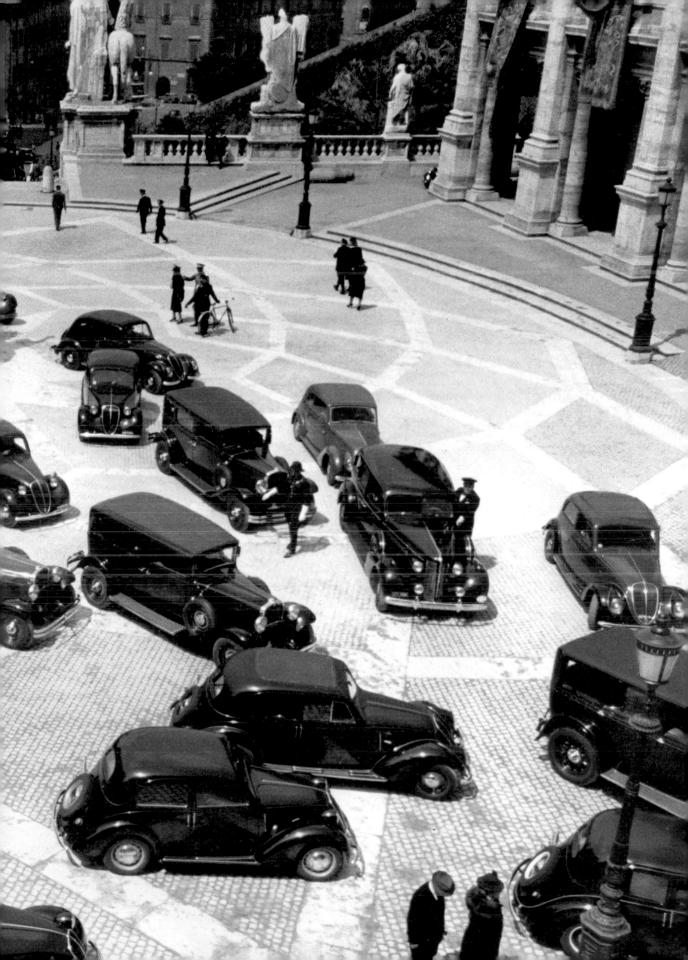

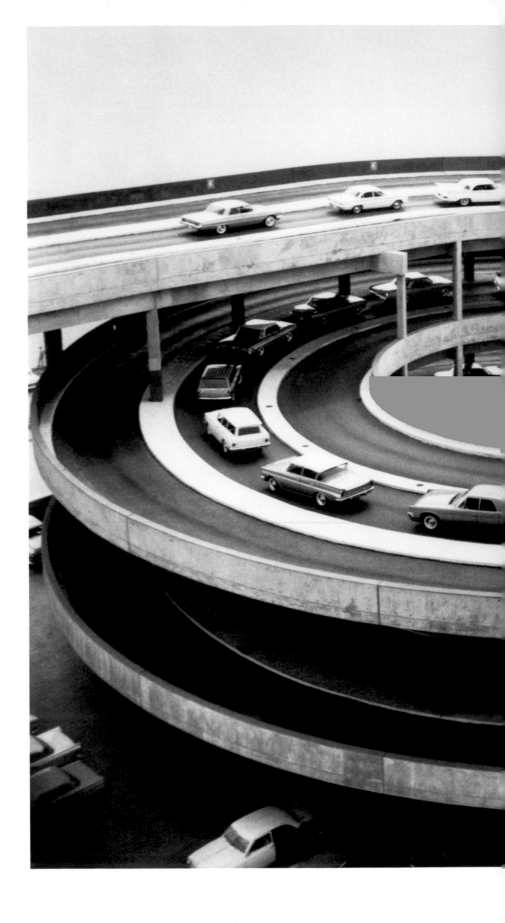

New 1961 cars on display on futuristic ramp at Cobo Hall, Detroit, 1960 **Joe Clark**

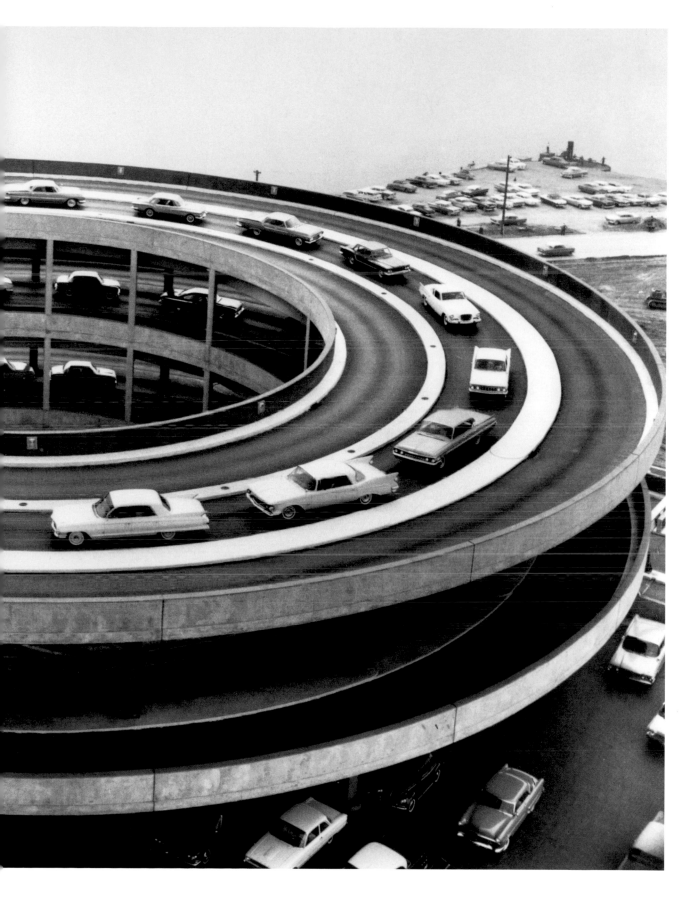

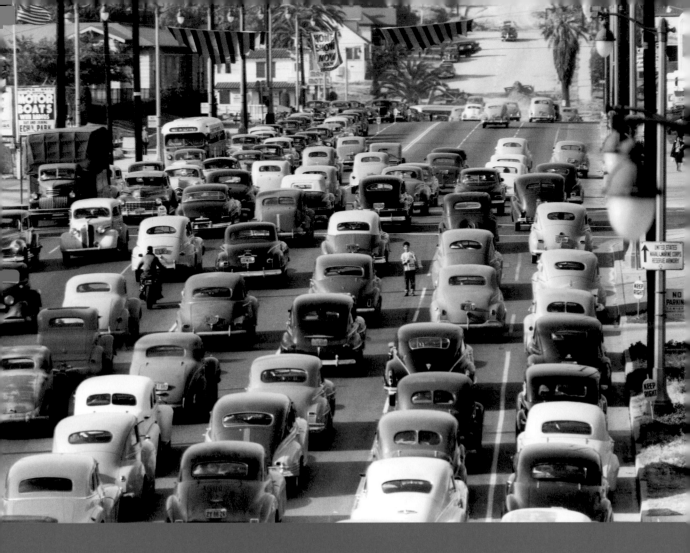

↑ Boy selling newspapers in Los Angeles traffic, at Figueroa and Sunset, 1949 **Loomis Dean**

→ Fifth Avenue, looking north from Thirty-second Street, New York City, 1948 **Andreas Feininger**

OVERLEAF The *South Western Limited* speeds away from the station, 1952 **Alfred Eisenstaedt**

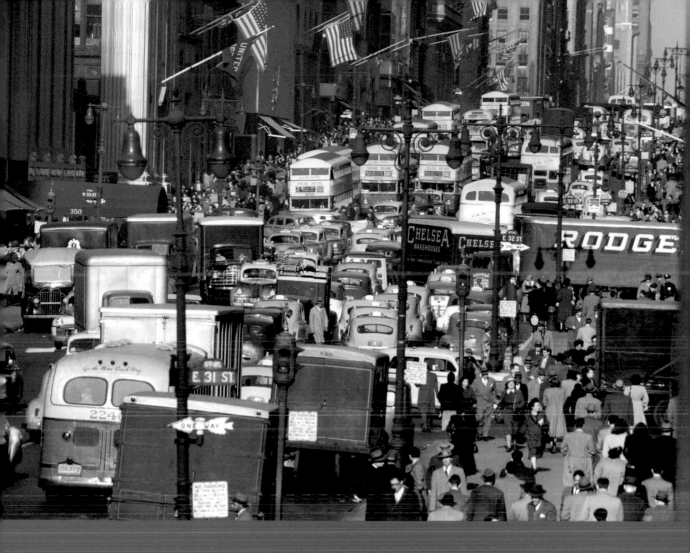

PROCEEDING SLOWLY,
PAST HIS OLD BUILDING, PAST GARAGES,
past bar and grills, past second-rate hotels, he followed the traffic further downtown. He drove into the deepest part of the city, down and downtown to the bottom, the foundation, the city's navel. He watched the shoppers and tourists and messengers and men with appointments. He was tranquil, serene. It was something he would be content to do forever. He could use his check to buy gas, to take his meals at drive-in restaurants, to pay tolls. It would be a pleasant life, a great life, and he contemplated it thoughtfully.

Stanley Elkin, "I Look Out for Ed Wolfe"

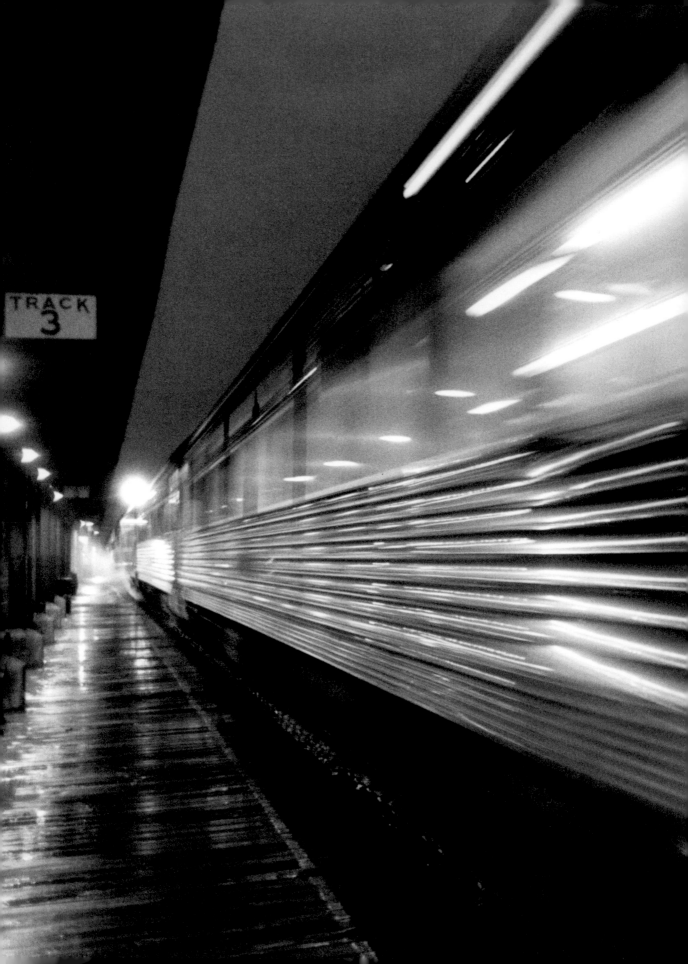

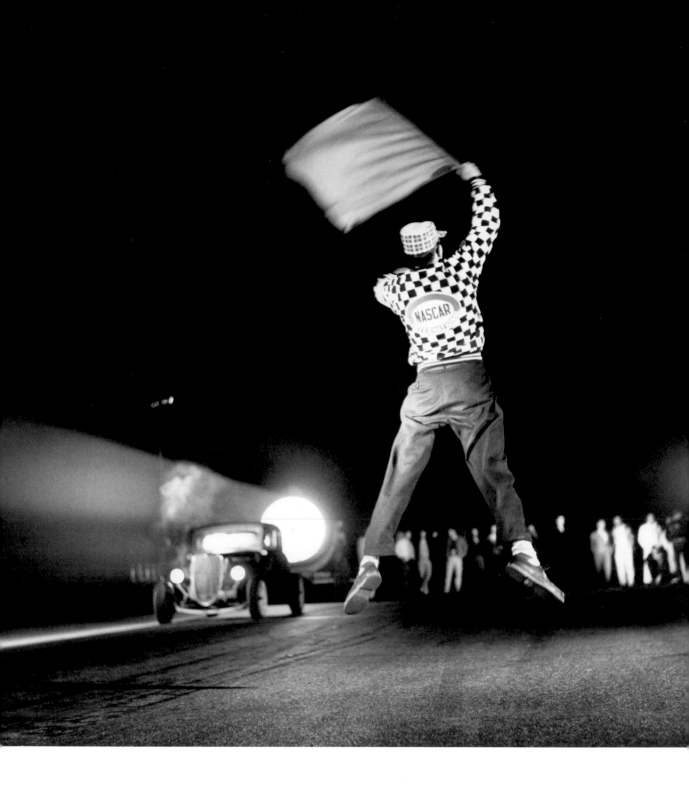

Drag racing, 1957 **Hank Walker**

Teenagers racing hot-rod cars, Los Angeles, 1949 **Ralph Crane**

OVERLEAF Brooklyn Dodgers fans celebrating World Series victory,
Flatbush Avenue, Brooklyn, New York, 1955 **Martha Holmes**

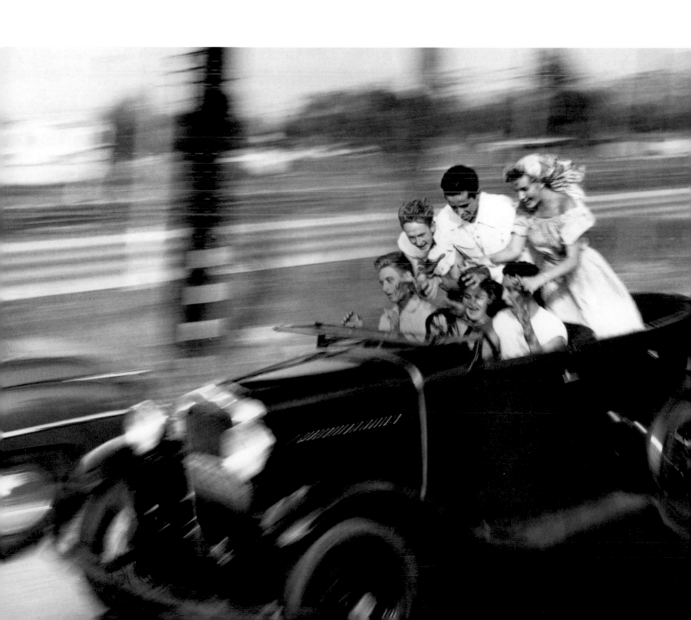

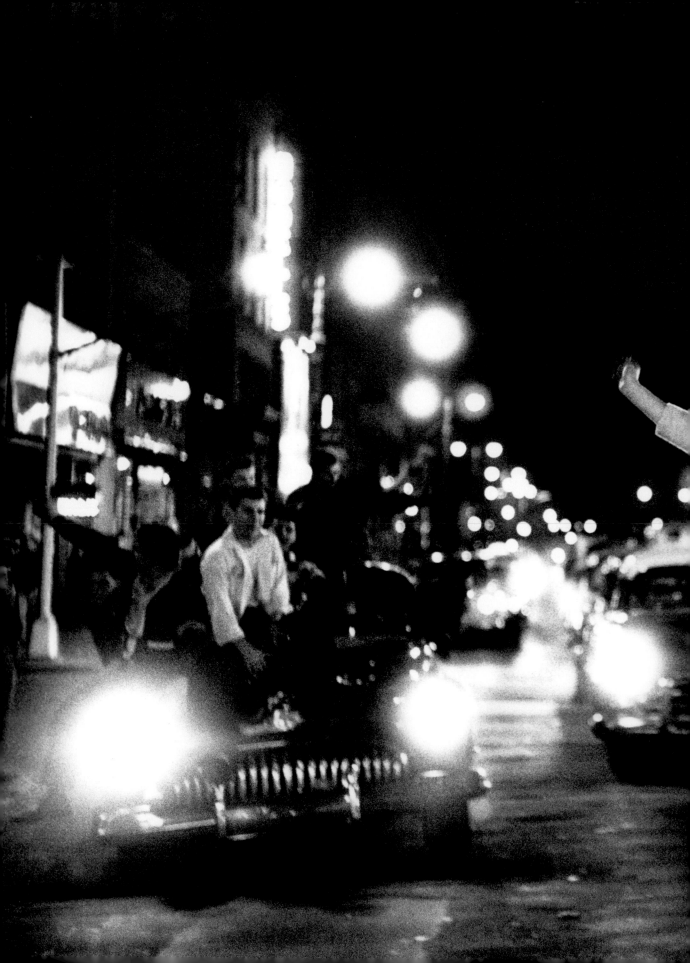

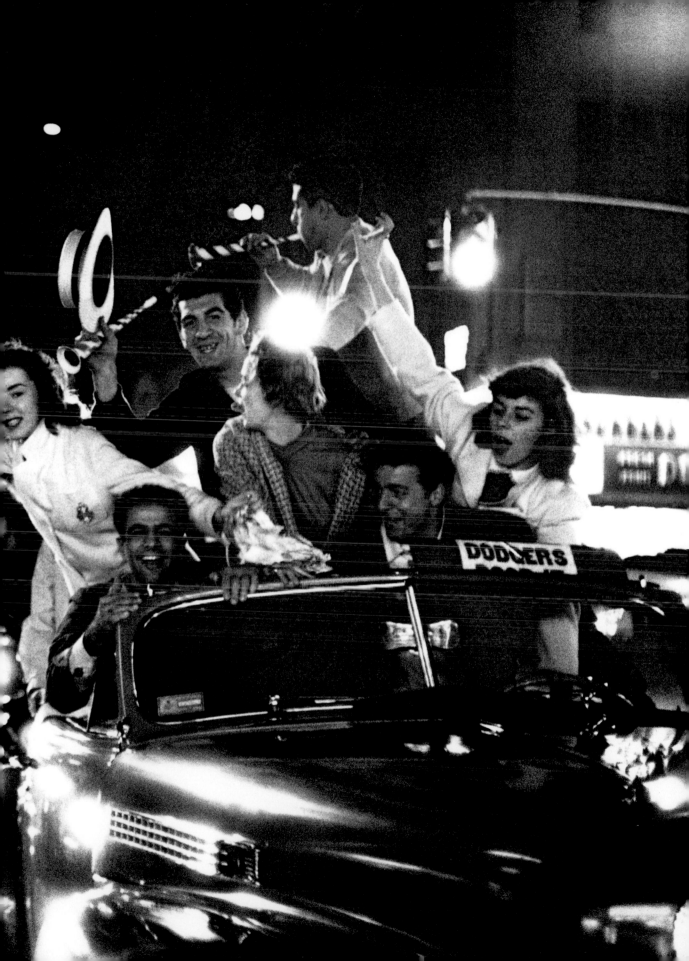

INDEX OF PHOTOGRAPHERS